A COLLECTION OF LIN MINGGANG'S PORTRAIT SKETCHEA

林鸣岗素描肖像集

朱膺题

当代名家
素描画典

河南美术出版社
Henan Fine Arts Publishing

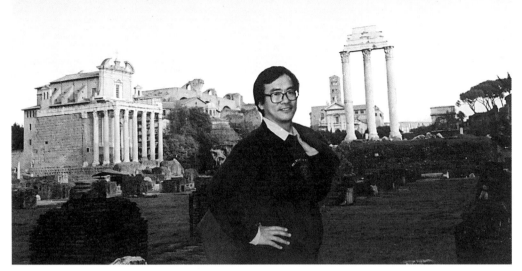

林鸣岗近影

Jè soussigné, Carron Pierre.
Certifie que monsieur Lin Minggang
a travaillé dans l'atelier, où il
était inscrit en qualité d'invité.

déjà qualifié, Diplomé de l'école
des Beaux Arts de Hong Kong, il y achève
ses études, et se consacre au dessin.
choisissant le thème de la "tête d'expression"
, il en resulte des dessins, lesquels,
témoignent de ses capacités et où
il fait preuve d'une grande habilité

Pierre Carron.

……林鸣岗所选择的"表现性头像"主题，充分显现了他素描方面的娴熟技巧和卓越的才能……

皮埃尔·卡隆

国立巴黎美术学院
教授　著名画家

真情的呼唤

——读林鸣岗的素描

"作为一个画家，他仅仅需要具备一个条件就足够了，那就是对艺术的无限热爱和对大自然的无限忠忱。"

柯罗

当我在林鸣岗的巴黎寓所看到他近年来画的那些动人的素描肖像的时候，我脑子里立刻浮现出柯罗的这一句话。

为了纪念这位大师二百周年的诞辰，大皇宫里正在举行着盛大的柯罗回顾展。柯罗在他漫长的艺术生涯中，以他对艺术纯真和执著的追求，以及他面对法国乡村景色的默默钟情，创造了他独有的清新画风，从而使巴黎画坛为之一振，他几乎横扫了他前辈所依依不舍的沉闷和保守的宫廷气息，更使得一度充斥于绘画中的软绵绵的脂粉气味落得无地自容。从此，法国艺术开始了巴比松画派，以及随之而来的印象派健将们叱咤风云的一代雄风。从这个意义上来说，这位有着法国农民的朴素外貌的老人，其实是一个内心充满着激情的画坛革新派主将，他的艺术活动催生了整整一个多世纪的法国艺术高潮。

林鸣岗出生于中国南方的福建省，但是他那结实的身躯、粗重的嗓音和豪爽的性格，却使人感到他似乎更像生长在中国黄河流域的北方汉子。相传具有"南人北相"的人是幸运的。林鸣岗终于在38岁那年闯荡到这个闻名于世的艺术之都巴黎来了。巴黎的艺术气氛滋养着这位来自中国的艺术家，使他一步步地走向成熟。

林鸣岗的"南人北相"的气质，我认为反映在他的素描艺术上就是呈现出一种质朴的气度。他很少像中国南方画家那样常有的对明丽风格的追求，多数南方画家的作品往往飘逸洒脱或者锋芒毕露，但这种过分的聪明却使素描趋向于柔弱；过多地关心技巧的精美和显示个人的才华反而使素描失之于纤巧。得之于"术"而失之于"道"，"娇娇者易折"，说的就是这个现象。而在总体性格上更接近中国北方人的林鸣岗所具有的诚挚、豪迈的个性，使他在艺术追求上很靠近法国巴比松画派大师们的那种气质。他的素描朴实无华，决无娇柔造作，可是却光彩夺目。而这一点恰是素描艺术所以感人的真谛。正因为素描艺术运用着最简单的绘画工具，他也仅具备线条和光影两种艺术手段，技巧语言降到无可再少的时候，使观众感到的就剩下画家的一腔真情了。我们纵观所有大师们的素描都是如此。而所以运用着如此简练的绘画语言的素描仍然呈现着气象万千的艺术魅力，原因也仅仅因为有着"画如其人"这个原因。每个画家独特的个性和情感，他们不同的艺术理想和艺术修养，这些都将在他们的素描艺术中焕发出各自不同的光彩。观众面对不同时代大师的作品就好像面对着

大师与之交谈一般。透过一幅幅小小的画面，透过那几根灵动的线条，或者一片片好像不经意涂抹的光影，我们就觉得看到了大师们那鲜活的灵魂，感觉到了大师们那深沉的呼吸，听到了大师们那清晰的脚步声声。

林鸣岗得到巴黎美术学院学习的机会已经是年近四十的中年人了。他还得克服语言上的障碍，但对艺术的酷爱使他如饥似渴地汲取着欧洲艺术精华的营养，他全身心地投入到卢佛尔宫去。面对伦勃朗、哈尔斯、大伟、柯罗等大师的原作进行临摹，从中研究大师们精湛的技艺，为此，他得益匪浅。这个阶段的扎实学习使他在绘画技巧上产生了一次质的飞跃。所以我们不难看到他在这一批动人的素描肖像中，是如何妥善地处理绘画技巧和情感抒发之间的关系的。说林鸣岗的素描是真情的呼唤应该不是过分的赞誉。他的素描中可以看到熟练的技巧为浓浓的感情所包容，从而显示出一种朴素淳厚的风格。林鸣岗这样一个体魄强健的男子汉，在每次素描过后往往大汗淋漓，精疲力尽，这并不是因为在体力上付出了沉重的负担，恰恰是因为感情上的全神贯注使然。他每每面对着动人的模特而激动得无法自制。他真的是以自己一颗热情跳动着的心在作画，而不仅仅是用他的一双手。

林鸣岗的这一系列肖像画，其对象大都来自于巴黎底层社会的普通人，其中相当多的人过着并不富裕的生活，但是，他们快乐、善良、正直。翻阅这些素描，我就觉得好像又一次来到了巴黎古老的拉丁区，漫步在那狭窄的石块砌成的小街上，非洲黑人的击鼓手以及印第安人的排箫声喧闹而又使人热血沸腾，那一间间希腊小餐馆或咖啡馆中挤满了人群，他们悠闲地在高谈阔论，一面品尝着香味扑鼻的烤羊肉和波尔多红葡萄酒……。林鸣岗就生活在他们中间，是他们可以依赖的朋友。林鸣岗熟悉他们的喜、怒、哀、乐，了解他们的苦闷和愉悦。作为艺术家，林鸣岗关心他们，同情他们，也爱他们。是人性的共同东西感动了画家。正是林鸣岗这一可贵的品质，这些生动的人物形象在林鸣岗笔下的出现，才像山涧泉水那样流畅，那样自然天成，从而使看到这些肖像的人获得了一次美好的艺术享受。

当然，林鸣岗是非常重视人物的性格描写。从人物姿态的把握、面部神情的刻画、甚至头发、胡须以及皮肤质感的表现，每一个细节都不可能逃过林鸣岗那双具有敏锐观察力的眼睛。再经过他的分析和筛选，使得画面上出现的细节都汇入到总体形象的创造中去。无论是剽悍的《沉闷的人》，那倔犟的脖子；热情洋溢的《击鼓手》，那宽厚善良的大嘴；以及双眼满含悲怆凄凉的《席地而卧的朋友》，那粗砺的皮肤；还有被生活重压而扭曲了面部的《流浪汉》，那一双神色疲倦的眼睛。尤其是画的同一模特的《开心的酒鬼》和《受伤的酒鬼》，这两幅精彩的肖像，林鸣岗都通过那一双传神的眼睛巧妙地刻画了那饱经沧桑的善良的灵魂。旺盛的生命力以及美好的人性的光辉，组成了林鸣岗这一个系列的肖像素描主旋律。正是由于这一切，我的心被他的素描所深深地震动了。

中国沈阳鲁迅美术学院
学术委员会主任、油画系教授

一九九六年四月于巴黎

A CALL FOR TRUE PASSION

A Review of the Setches by Lin Ming gang

"To be a painter, the only thing that is required is an
unlimited love for art and nature"

Corot

This remark of Corot's immediately came to my mind when I saw the exciting sketches made by Lin over the last couple of years in his Paris studio.

To commemorate the bicentenary of Corot's birth, the Grand Palais is currently holding a large-scarle retrospective exhibition of this great artist. In his long career Corot created a unique and refreshing style. He was consistent in his practice of a true art form and was silently passionate about the French landscape. His art shocked the Parisian art world and almost completely swept away the stale and conservative courtly style of art to which his predecessors still clung. But after Corot the polite and cosmetic art which once filled every canvas was made to feel out of place, and French art began a new era with the arrival first of the Barbizon and, hard on their heels, the Impressionists who conquered the world. In this sense Corot , who had the features of a simple French farmer, was in fact a forerunner of the new movement in art whose paintings were full of passion; his art was the catalyst propelling French art to its zenith for over a century.

Lin Ming gang, although born in Fujian (Fukien) China, has the solid stature, the deep voice and openness which make one feel that he is more a typical northerner born and bred on the banks of the Yellow River. There is an old Chinese saying "A southerner with a norterner's characteristics is always lucky" and Lin at the age of 38 at last realised his ambition to come to Paris. Even though he had already made a name for himself in the Hong Kong art world, he still came to the art capital of the world to pursue his art in spite of the language barriers and cultural differences. And the artistic atmosphere of Paris has been daily meat and drink to him, and the nourishment it provided has made his artistic career reach a higher maturity.

Lin's character of a "southerner with northern features," in my view is reflected in his works which express a simple and unadorned nature. In this Lin is very unlike the majority of artists from southern China, who usually use a style distinguished by bright and pretty colours so that their paintings frequently appear to be both delicate and at the same time obvious. This over-refinement often makes their sketches seem weak and lifeless; as placing too much emphasis on the perfection of skills and the demonstraction of artistic talents makes the sketches lose their originality, so that technique is gained at the expense of artistic truth. "A proud person is easy to dissect" precisely describes this phenomenon. However, Lin, being more like a northerner, has a very honest and sincere individual style which is in spirit close to the style of the artists of the Barbizon school. His sketches are simple and unadorned, free from any artificiality, and yet they are full of life. This is exactly why sketches can move one's heart; sketching employs only the simplest drawing tools,using nothing but lines and shadows to create the desired effect.When this technique is simplified to its bare minimu, all that is left for the viewer to see is the feeling of the artist's true passion.Sketches by great artists always affect people in this way and this is why sketching still holds its magical power .Furthermore because sketches reflect an artist's true emotions and as each artist has his own unique individuality and emotion,Different artistic aspirations and training have made each artist shine in his own way in the art of

sketching .For the viewer looking at sketches by great artists of any period is like talking directly with the artists themselves through each small scene. Through the few lively lines or patches of shading apparently put down at random we get a feeling that we are seeing the living souls of the grand masters .Feeling their deep breaths and clearly hearing their footsteps.

When Lin at long last got the opportunity to study in the Paris Academy of Beaux Arts. He was a mature man of nearly 40.Even though he still needsd to overcome the language barrier, his strong and passionate love for art made him hungrily absorb the essence of all the best European art .He spent many happy hours in the Louvre diligently copying works by artists such as Rembrandt,Frans Hals, David ,and Corot.From these works he studied the superb techniques of the great masters which had a great and beneficial in fluence on his art. During this period of unremitting and earnest study, Lin made a substantial leap forward in his drawing techniques.Therefore it is not difficult to see how he has perfectly dealt with the relationship between techniques and personal feelings in this selection of portrait sketches . To say Lin's sketches are a call for true passion is certainly no exaggeration .In his sketches one can see how his perfect techniques are enhanced by his deep emotions which shows his unique style of simplicity and naturalness. Lin is physically very fit ,yet often after a sketching session he is drenched in sweat and exhausted , not because he has expended physical energy in his sketching, but because emotionally he is totally absorbed in his subject matter. Whenever Lin faces an exciting subject, he is totally absorbed in his work and withdrawn from the world; he is not merely using his hands to draw but also his heart.

Most of this series of portrait sketches by Lin are of ordinary people who comprise the bottom layer of Parisian society . Many of these sitters are from former French colonies or overseas territories or other European countries; they do not live a very abundant and plentiful life, yet they are happy in their own way and very kind and honest. Leafing through these sketches I feel as I am once again in the ancient Latin Quarter ,wandering through its narrow cobbled lanes where a black African is playing his drum, the panpipes of the Andeans are stirring one's heart, and small restaurants and cafes run by the Greek community are packed with people .They are leisurely chatting away while tasting the succulent kebabs and Bordeaux. Lin is living precisely among these people, he is a friend they can rely on ,he knows intimately their happiness, anger, sadness and joy in life . As an artist Lin cares about them ,sympathises with them and loves them. It is precisely because of this noble character of Lin's that these life-like images appear to flow from his pen with the fluidity and naturalness of a mountain spring; seeing them leaves the viewer with a sensation of enjoyment and appreciation of a wonderful artistic experience.

Of course, Lin also pays a great deal of attention to the techniques of depicting the character of his sitters.The posture, the exprssion, even the hair, beard and skin texture , every detail has been vividly captured by Lin's sharp observation. After analysis and selection , the details that remain have all converged in the creation of total image .No matter what it is , whether it is the stubborn neck of the strong "Silent Man", the broad-lipped generous mouth of the joyous "Drummer", the rough skin of "A Friend Sleeping on the Ground"with eyes full of sadness and gloom , the pair of tired eyes of the "Wonderer"whose facial expression has been twisted by the pressure of living and especially the two splendid portrait of the same sitter one titled"A Happy Drunk" ,the other "An Injured Drunk".Lin , through his pair of conscions eyes , has perfectly captured all those kind souls who have suffered so much .Vitality and beauty of humanity formed the main themes of this series of Lin's portrait sketches, and it is precisely this quality which makes his art leave such a deep impression on my heart.

Xu Rong chu
Paris, April, 1996

Xu is a Professor of Oil Paintings and Director of the Academy Committee of
Luxun Academy of Art, Shenyang , China . He is currently living in Paris.
Translated by Eileen GAO, Translator and writer, now Living in London.
Corrector: Kathy Rosen (U.S.A)

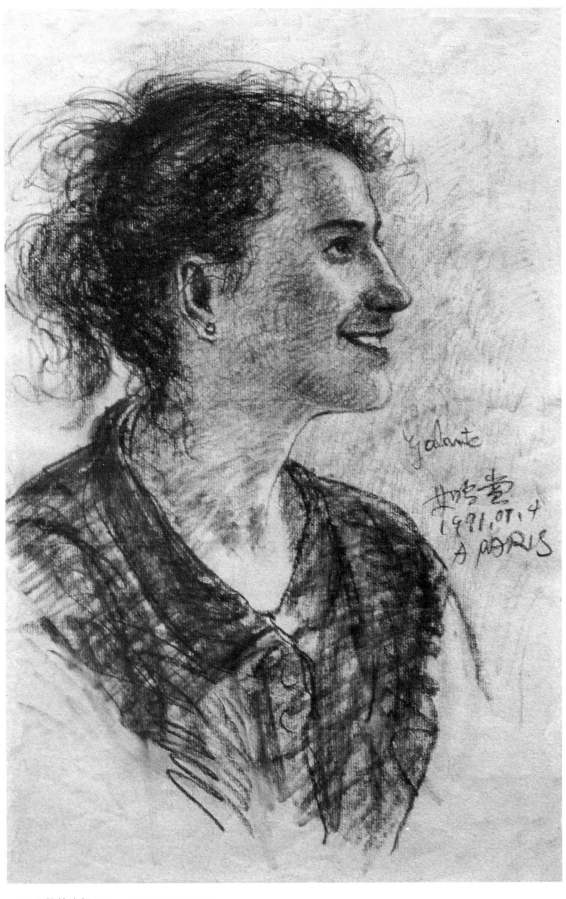

1. 亚拉特小姐 (32 × 50cm) 1991 色粉笔
Miss Yalarte pastel

2. 复塞尔小姐 *(32 × 46cm) 1991* 色粉笔
Miss Foucers *pastel*

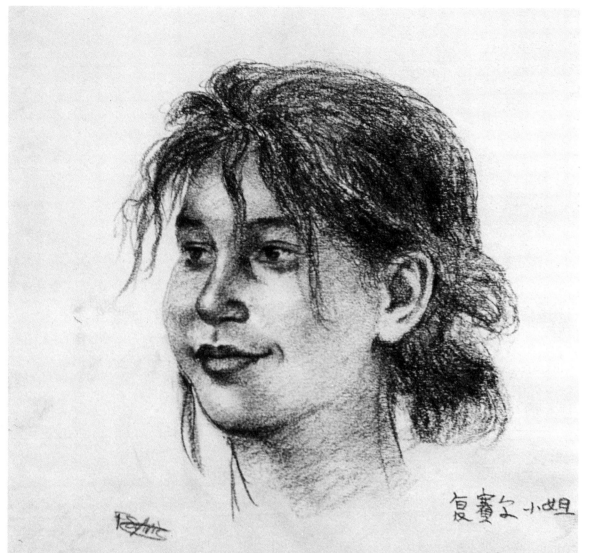

FOUGERES

复赛尔小姐

这是一个十分可爱的棕黑色
姑娘，急着为我当模
特儿，使我能看到
画了一张速写
九九年省日鸣冈
作于巴黎市近比
此其心门口

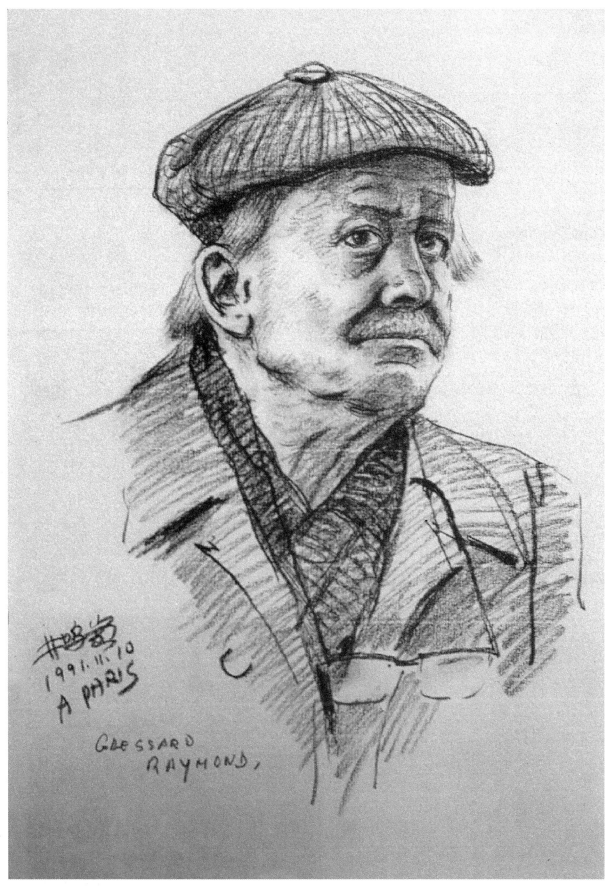

3. 戴帽的老头 *(32 × 44cm) 1991* 炭　笔

The red beret　*charcoal*

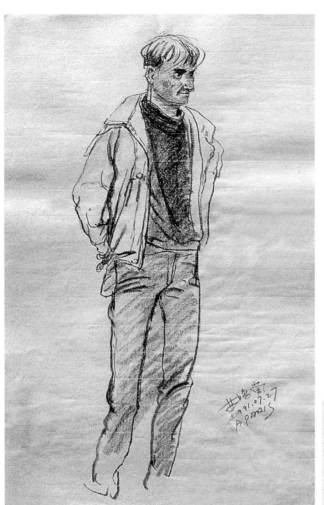

4. 路人
(32 × 50cm)
1991 炭 笔
The stranger
charcoal

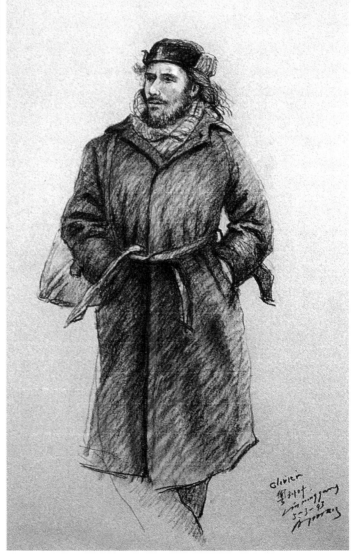

5. 远方来客
(32 × 50cm)
1993 炭 笔
Someone came from a
far-away place
charcoal

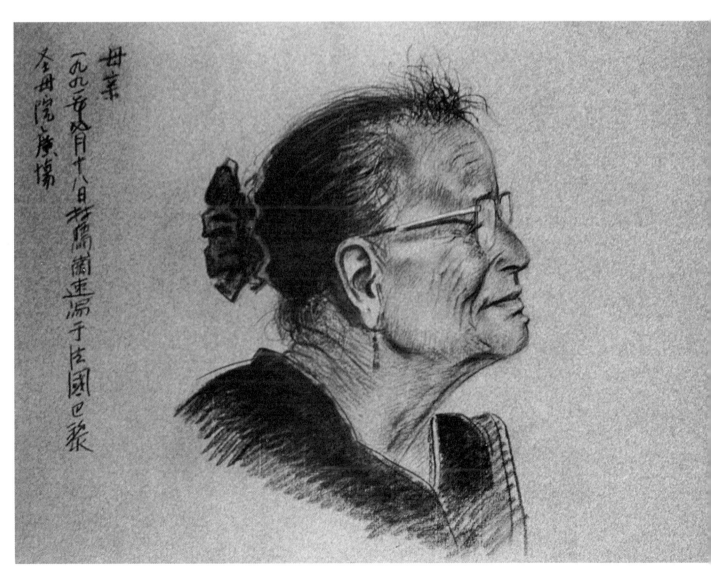

母亲

一九九五年四月十八日苏妮兰进临于法国巴黎

圣母院广场

6. 东尼妈妈 *(32 × 44cm) 1991* 炭　笔
Mather of Doney's　*charcoal*

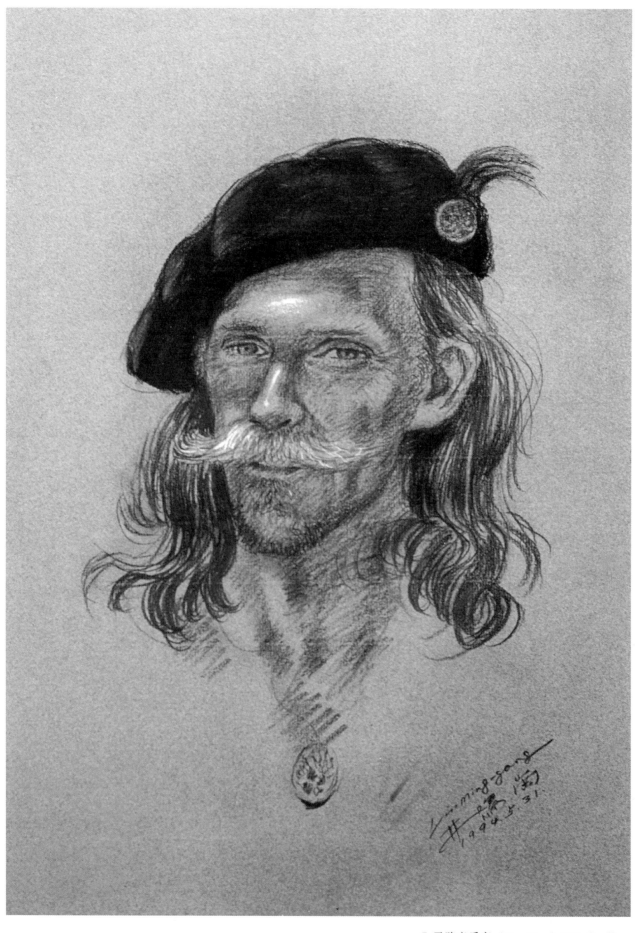

林鸣岗素描肖像集

7. 马路音乐家 (32 × 50cm) 1994 炭 笔
A roadside musician *charcoal*

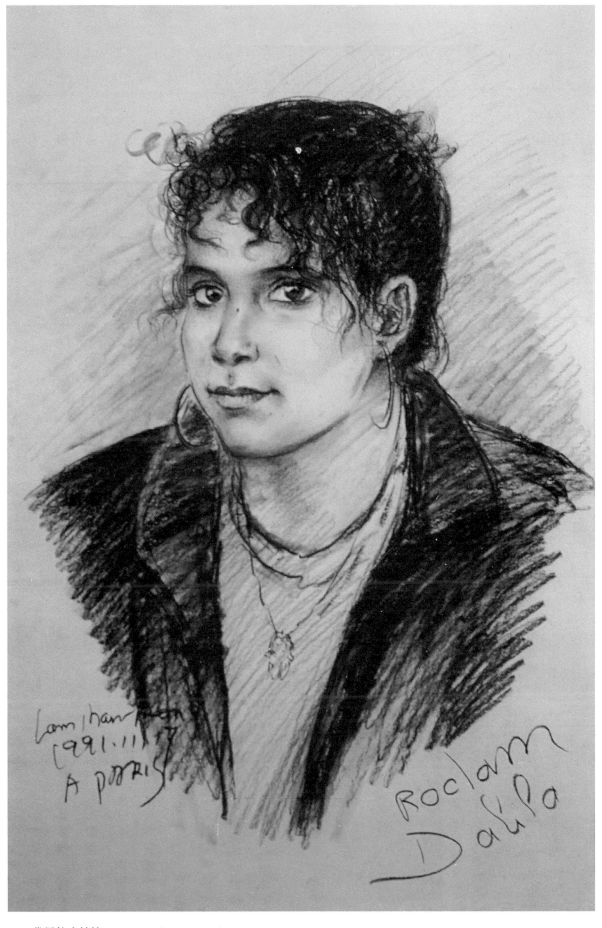

8. 黛里拉小姑娘 *(32 × 50cm) 1991* 炭　笔
Miss Dalila　*charcoal*

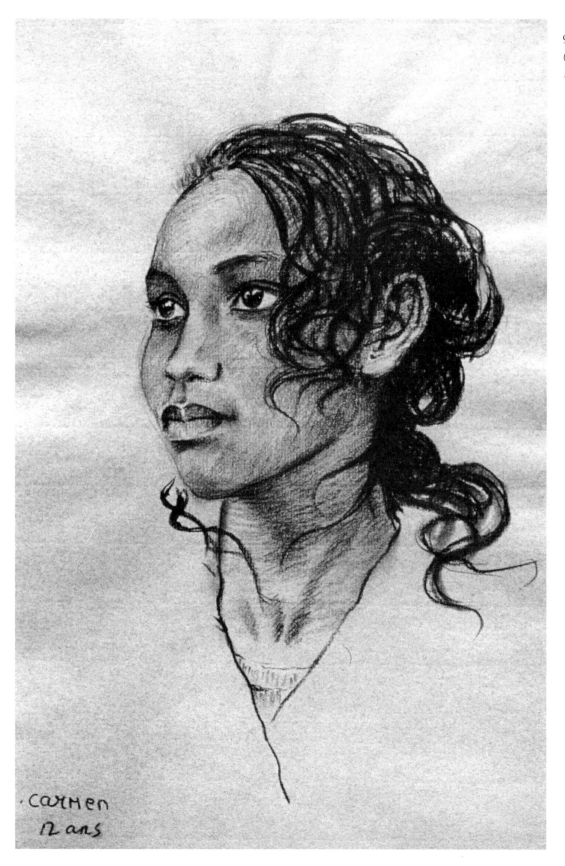

9. 加曼小姐
(32 × 50cm)
1991 色粉笔
Miss Carmen
pastel

· Carmen
12 ans

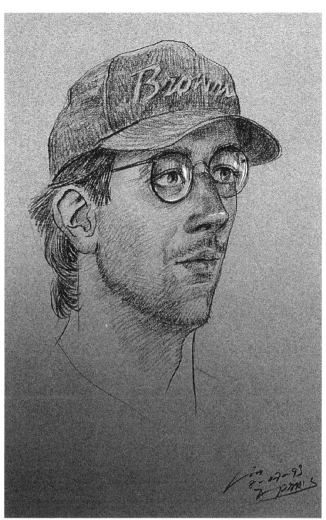

10. 戴帽的年轻人
(32 × 50cm)
1993 炭 笔
Youth man
charcoal

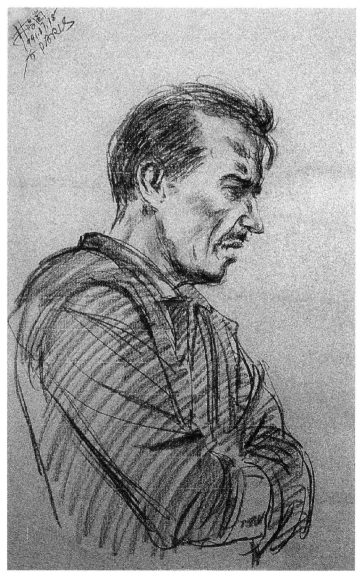

11. 小贩
(32 × 50cm)
1991 炭 笔
A peddler
charcoal

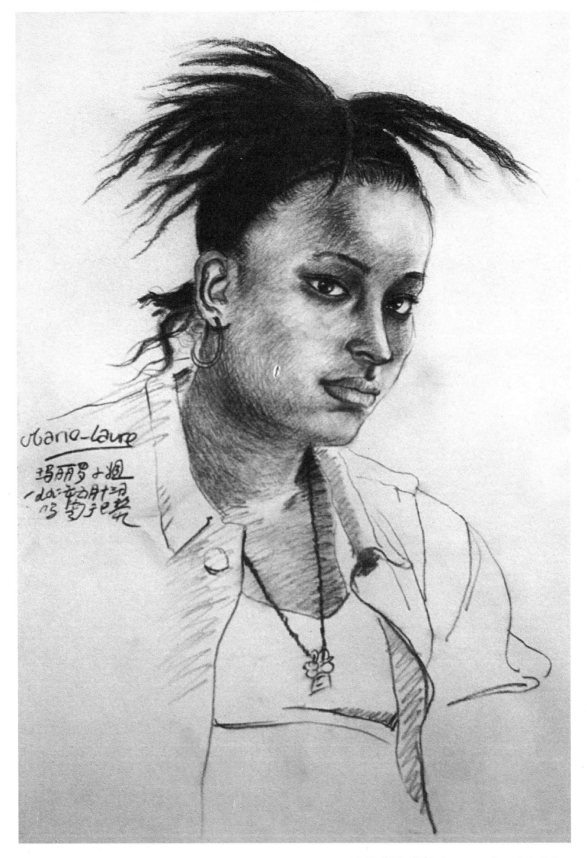

12. 玛莉罗．劳尔 *(32 × 50cm) 1992* 色粉笔
Miss Mario-Laure *pastel*

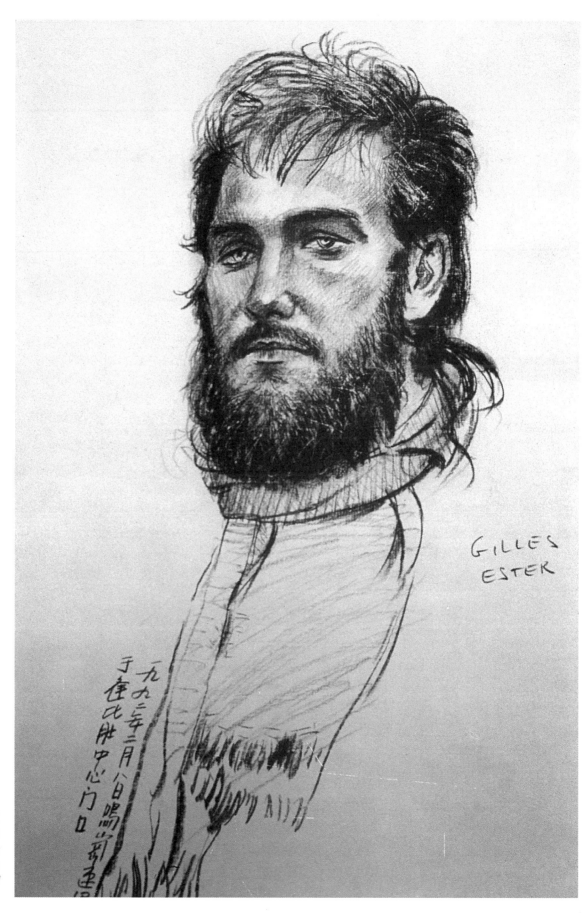

GILLES
ESTER

13. 流浪汉
(32 × 50cm)
1992 色粉笔
The homeless
pastel

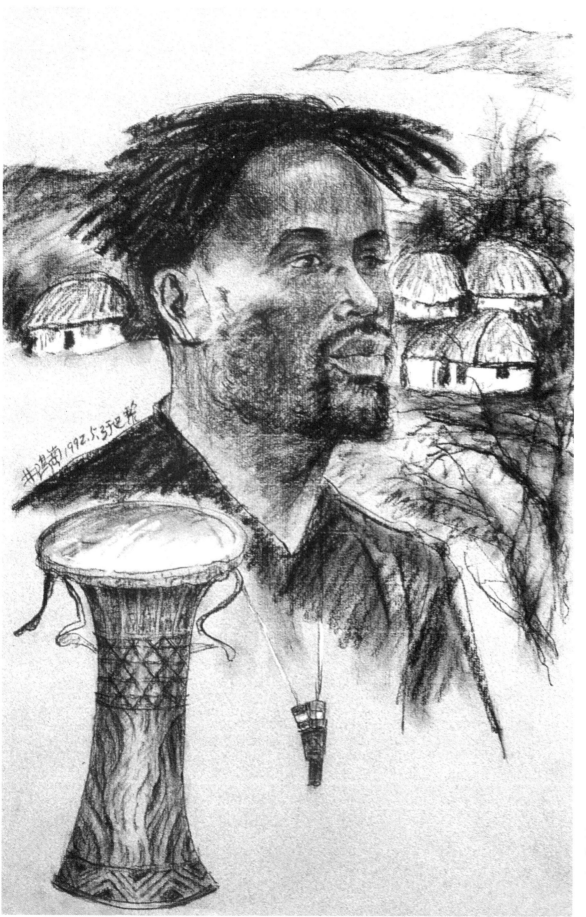

14. 击鼓手
(32 × 50cm)
1992 炭 笔
Drummer
charcoal

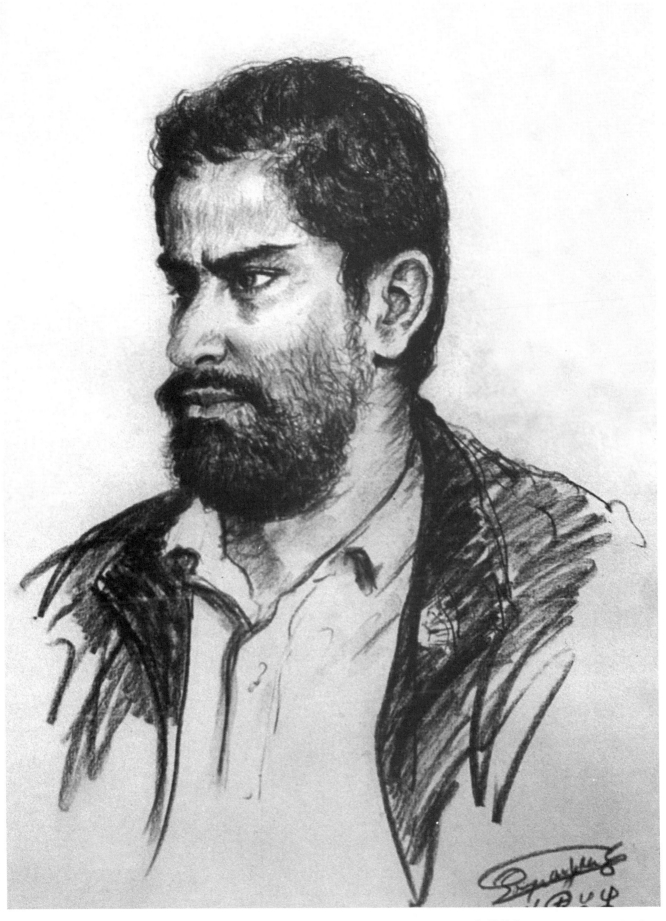

15. 沉默的人 *(32 × 50cm) 1991* 炭　笔
Silent man　*charcoal*

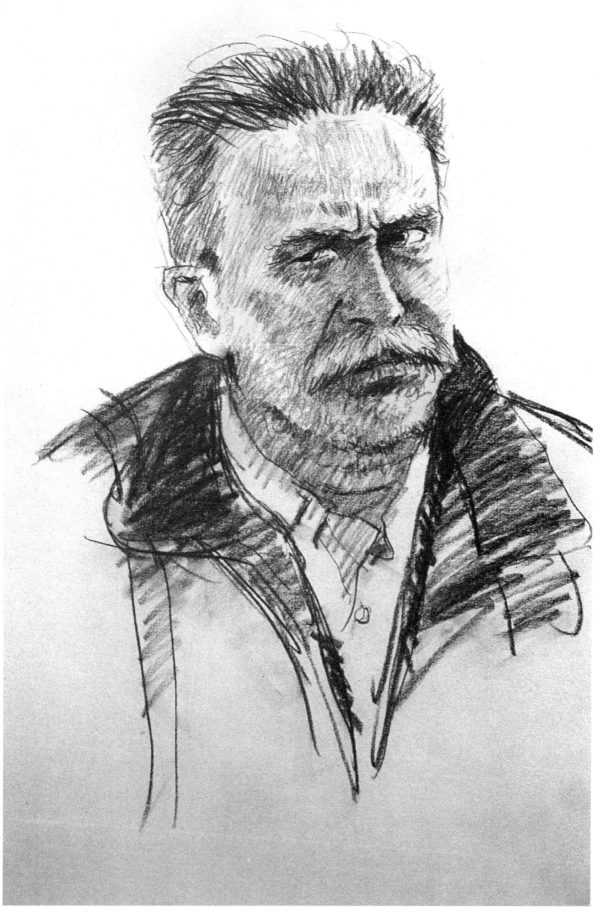

16. 观望 *(32 × 50cm) 1992* 炭 笔
observation *charcoal*

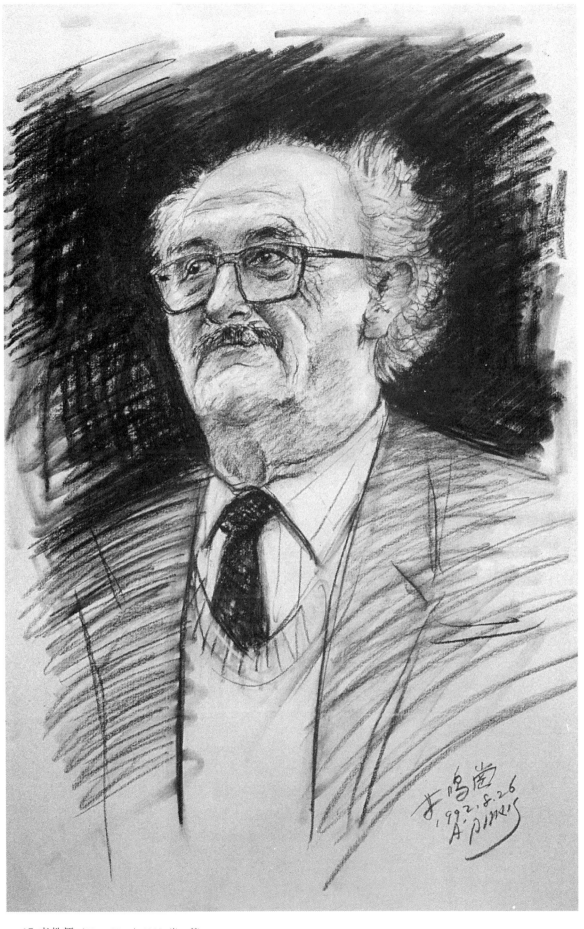

17. 老教师 *(32 × 50cm)* *1992* 炭　笔
An old professor　*charcoal*

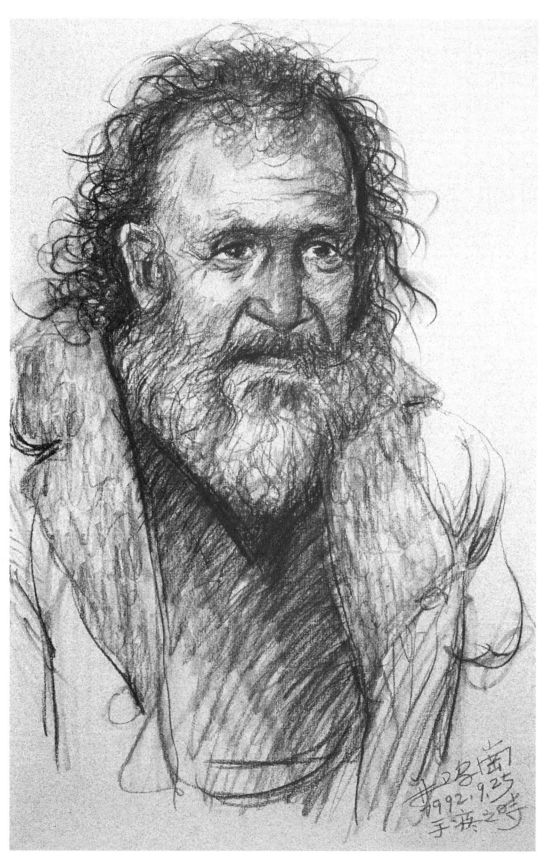

18. 流浪汉
(32 × 50cm)
1992 色粉笔
An old tramp
pastel

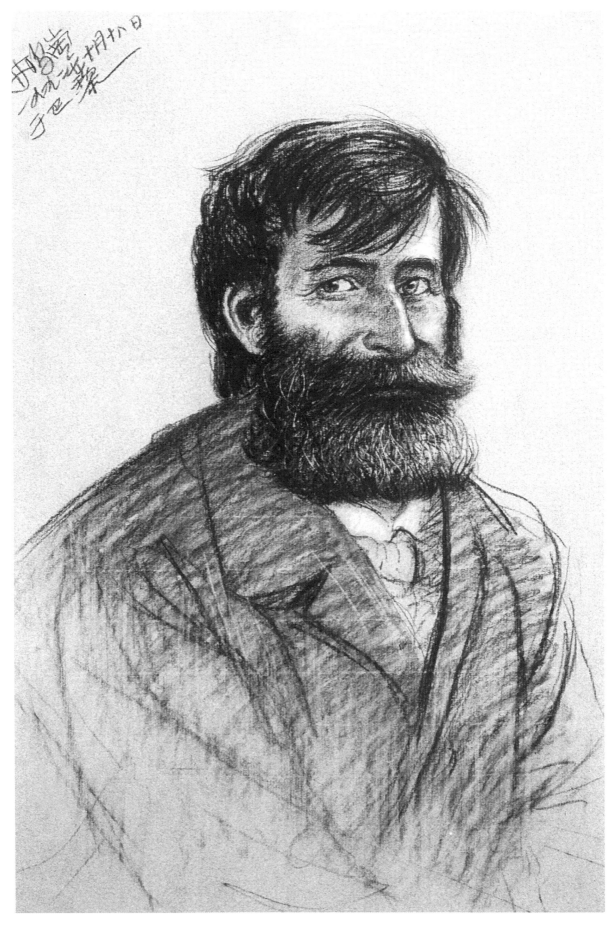

19. 一个教师的肖像 *(32 × 50cm)* *1992* 炭　笔
A portrait of an old teacher　*charcoal*

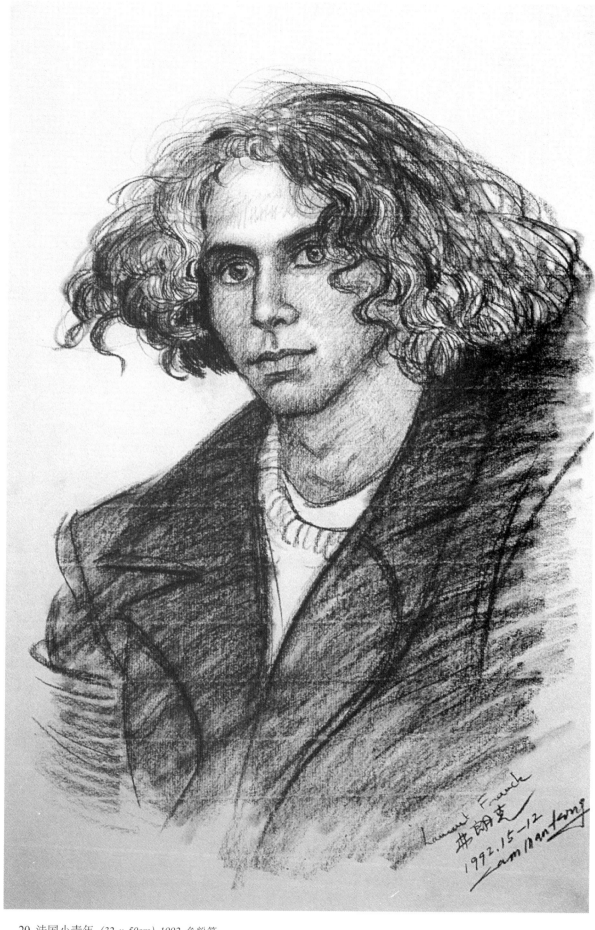

20. 法国小青年 *(32 × 50cm) 1992* 色粉笔

A youth of French *pastel*

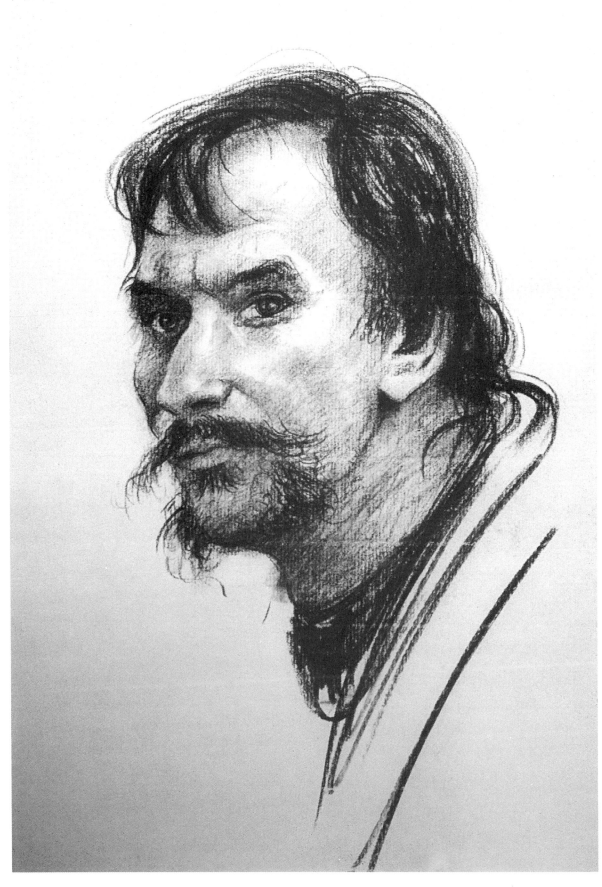

21. 小胡子 *(32 × 50cm) 1993* 色粉笔
The moustache *pastel*

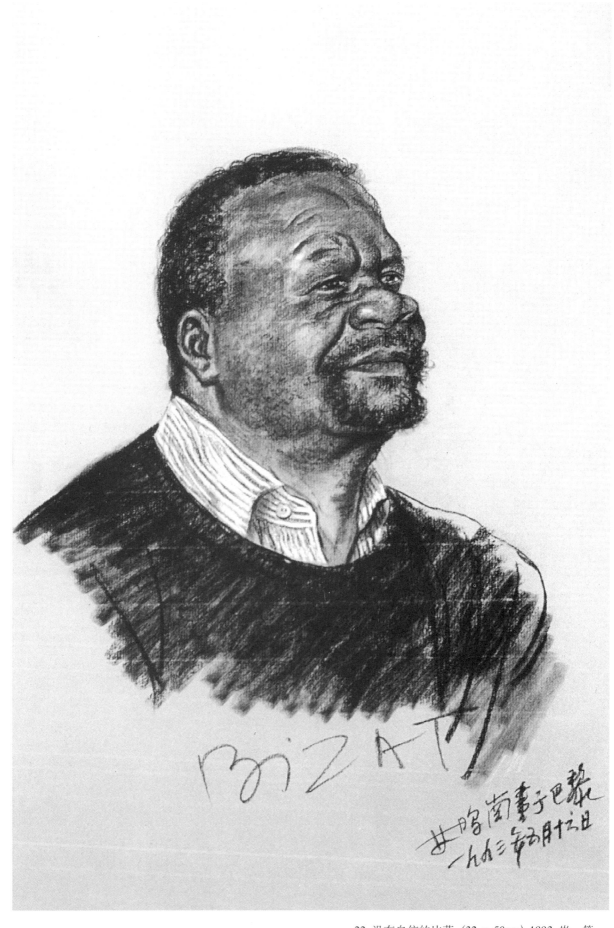

22. 没有自信的比萨 *(32 × 50cm) 1993* 炭　笔

Bizat lacking in self-confidence　　*charcoal*

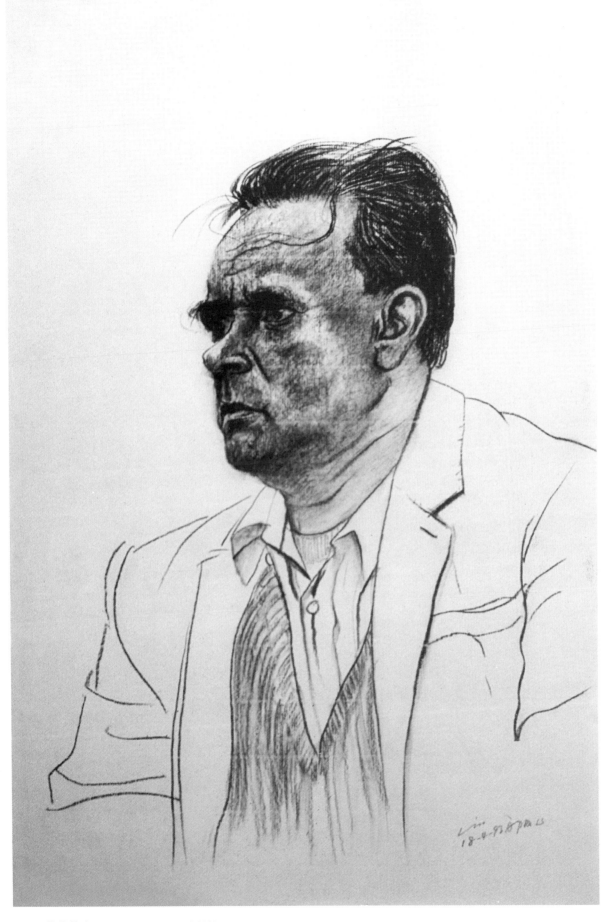

23. 彷徨的人 *(32 × 50cm) 1993 色粉笔*
A man hesitating at the crossroadsb *pastel*

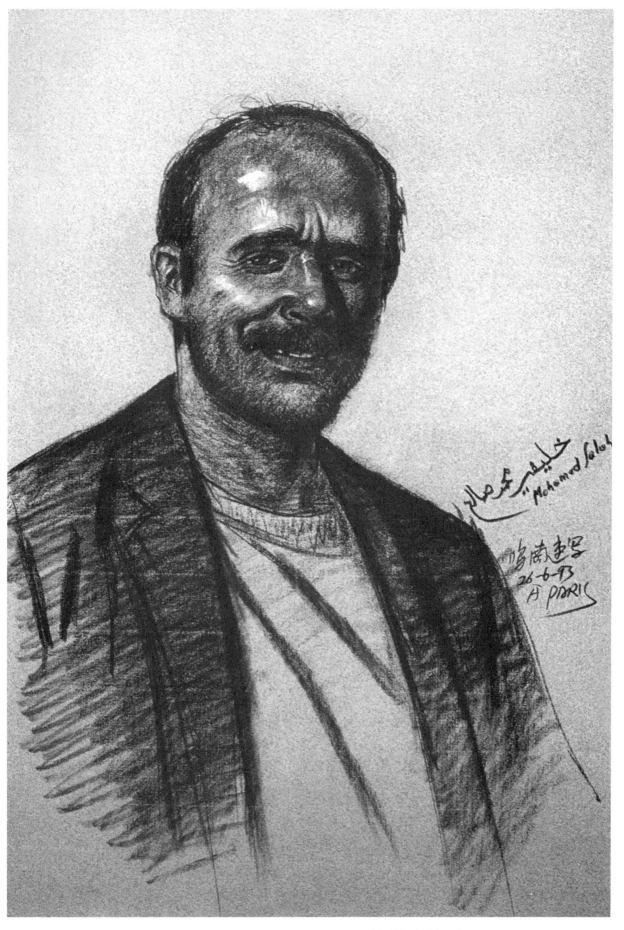

24. 开心的酒鬼（之一）（32×50cm）1993 炭 笔

A Happy Drunk *charcoal*

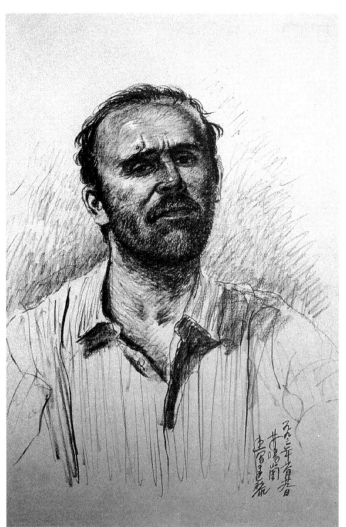

25. 受伤的酒鬼（之二）

(32 × 50cm)

1993 炭 笔

An Injured Drunk

charcoal

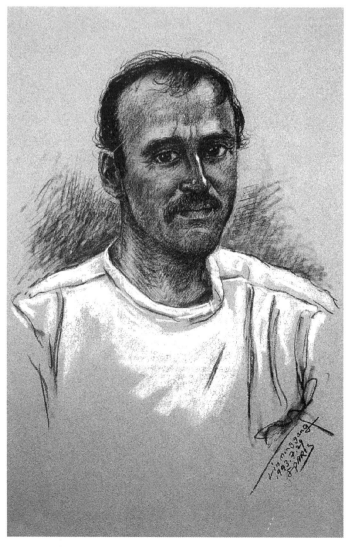

26. 酒后的酒鬼（之三）

(32 × 50cm)

1993 炭 笔

After drinking

charcoal

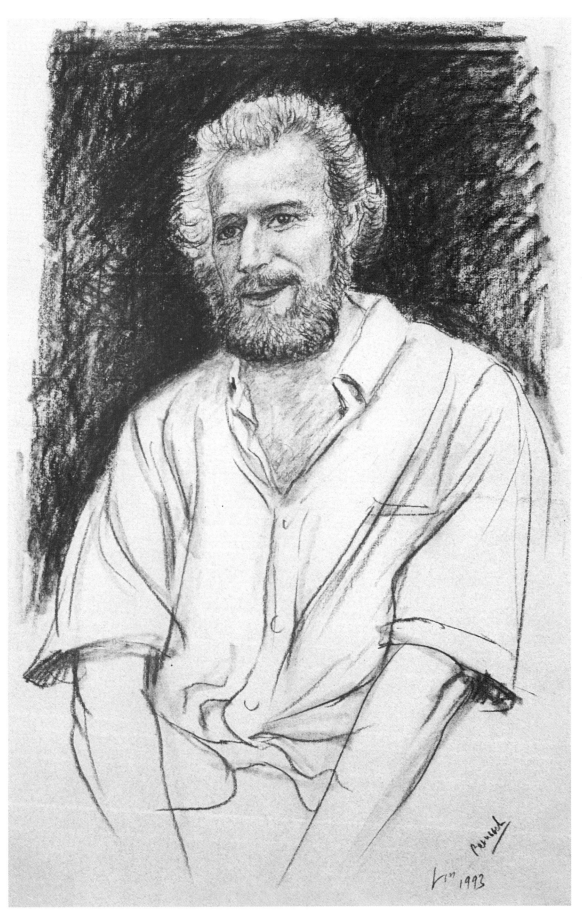

27. 失业者
(32 × 50cm)
1993 色粉笔
The Unemployed
pastel

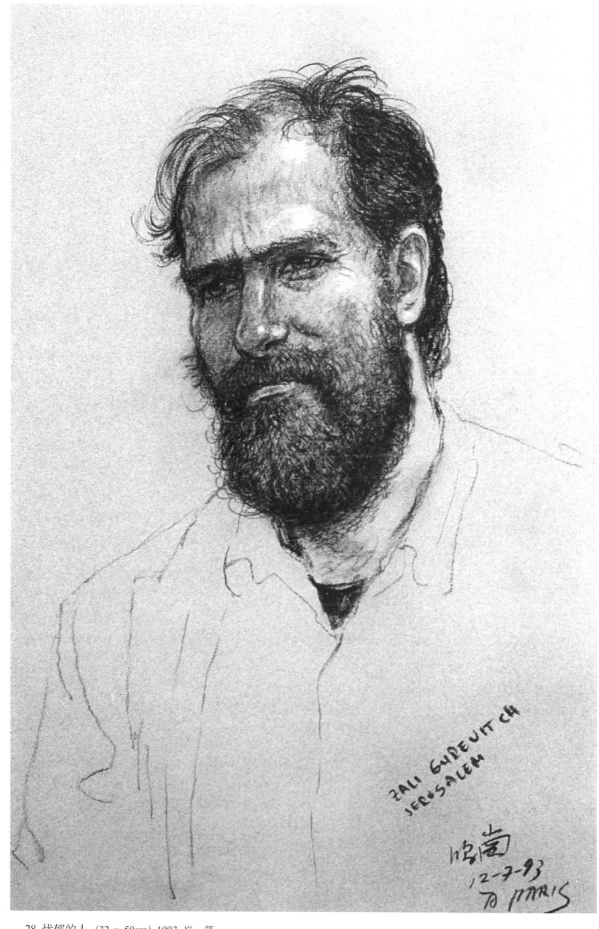

28. 忧郁的人 *(32 × 50cm) 1993* 炭　笔

The sad　*charcoal*

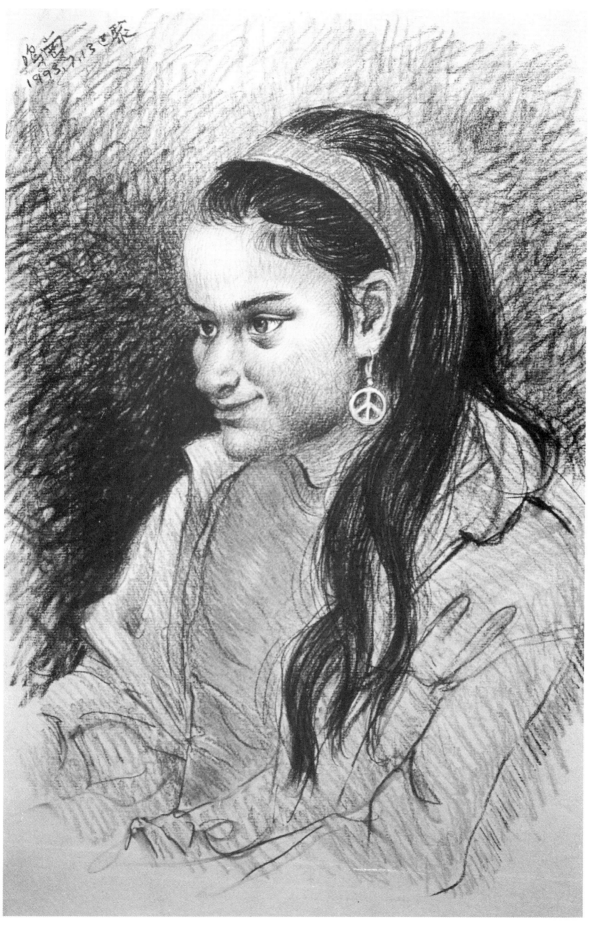

29. 印度小女孩 *(32 × 50cm) 1993* 炭笔、色粉笔

An Indian girl　*charcoal、pastel*

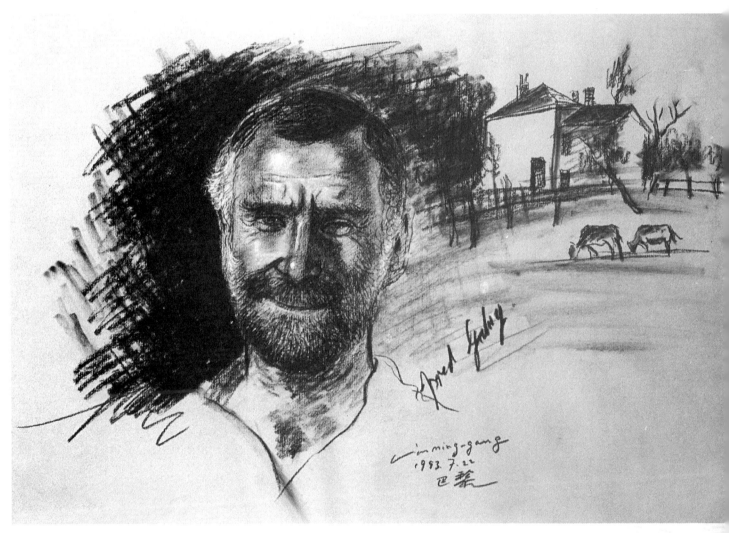

30. 开心的农夫 *(32 × 50cm) 1993* 炭　笔
A farmer filled with joy　*charcoal*

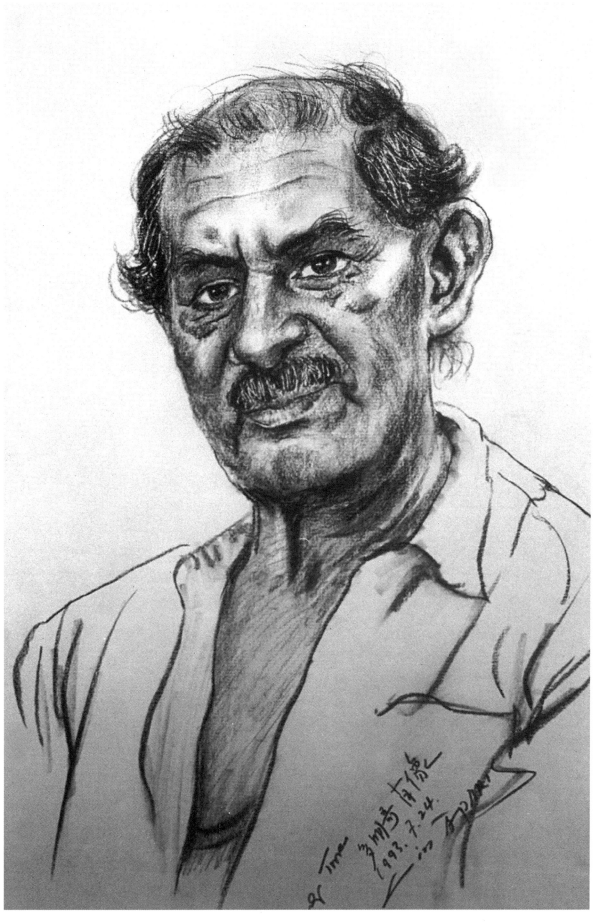

31. 多明哥肖像 *(32 × 50cm) 1993 炭　笔*

The portrait of Mr.Deming　　*charcoal*

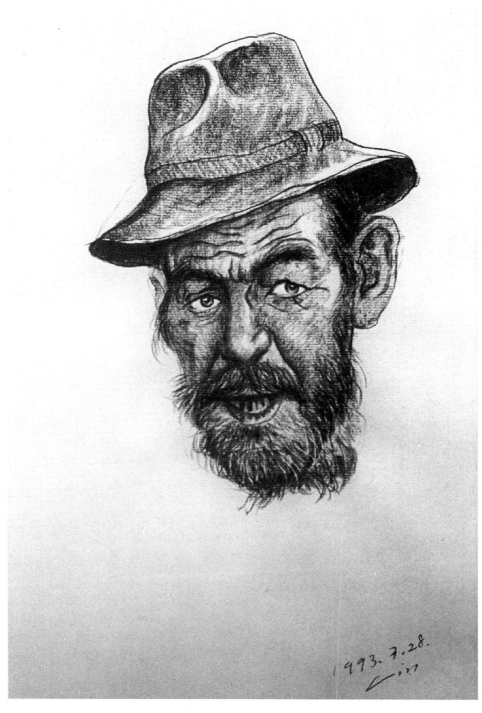

32. 老酒徒 (32 × 50cm) 1993 炭　笔
An old drunkard　*charcoal*

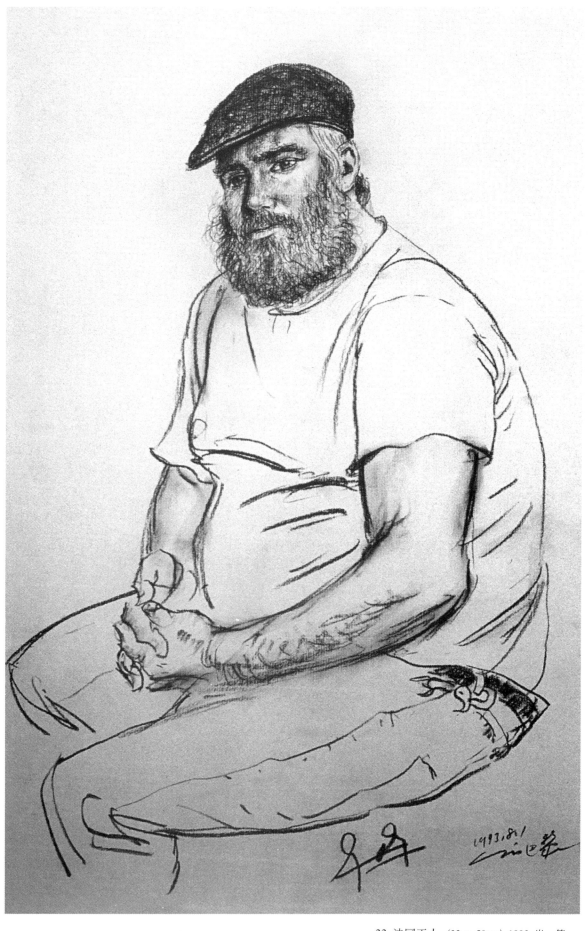

33. 法国工人 *(32 × 50cm) 1993* 炭　笔
A French worker　*charcoal*

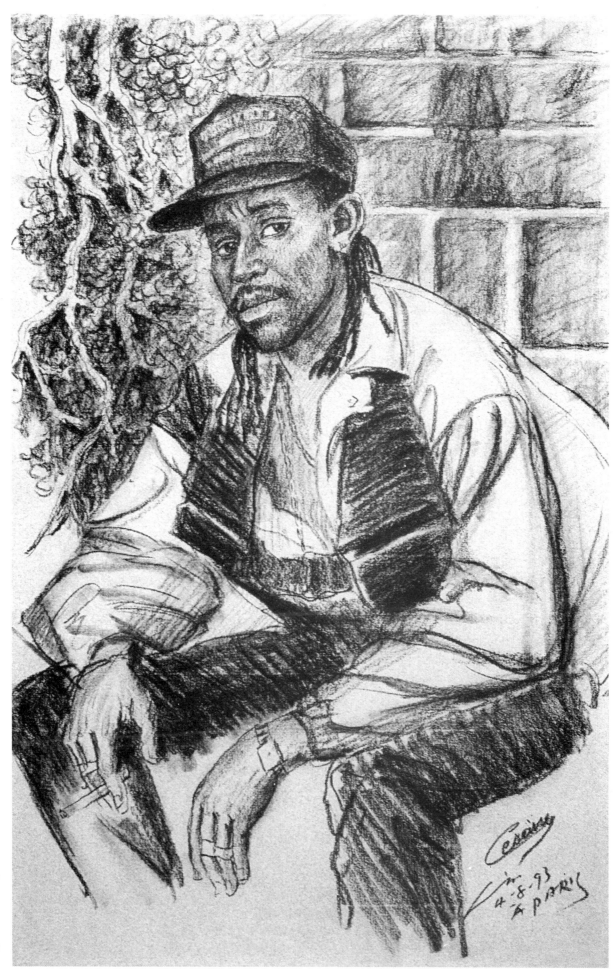

34. 南美的黑人
(32 × 50cm)
1993 炭 笔
A black man from
South-American
charcoal

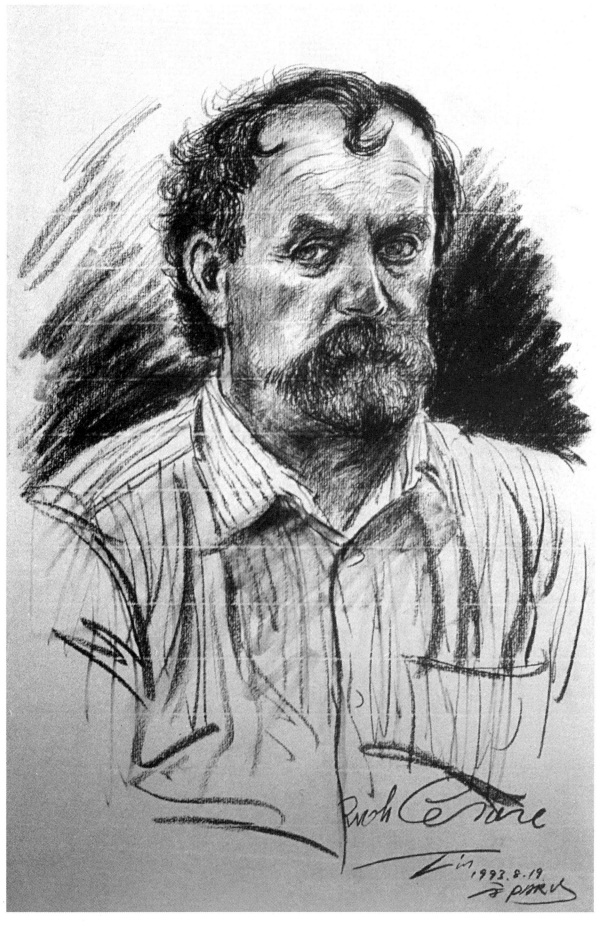

35. 老教授 *(32 × 50cm)* 1993 炭　笔

An old professor　*charcoal*

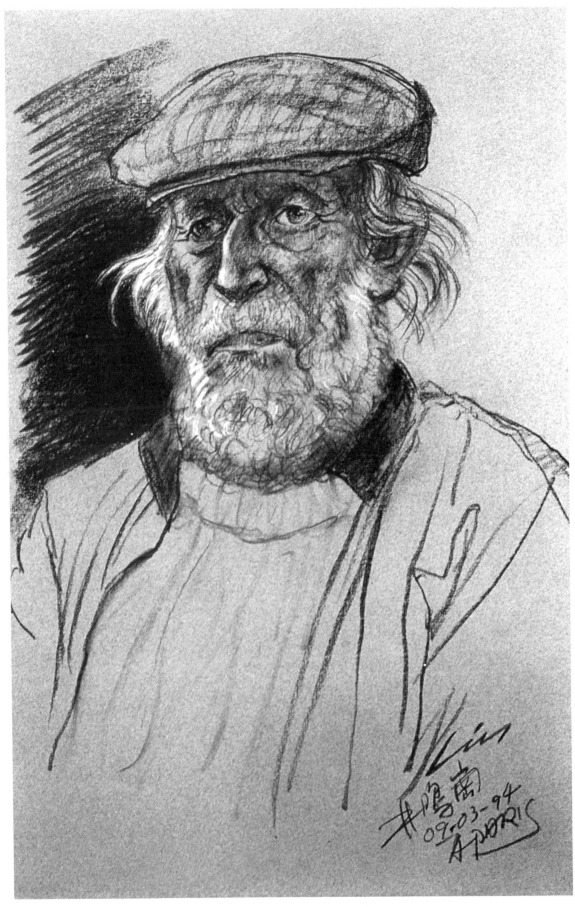

36. 哑巴
(32 × 50cm)
1994 炭 笔
The dumb
charcoal

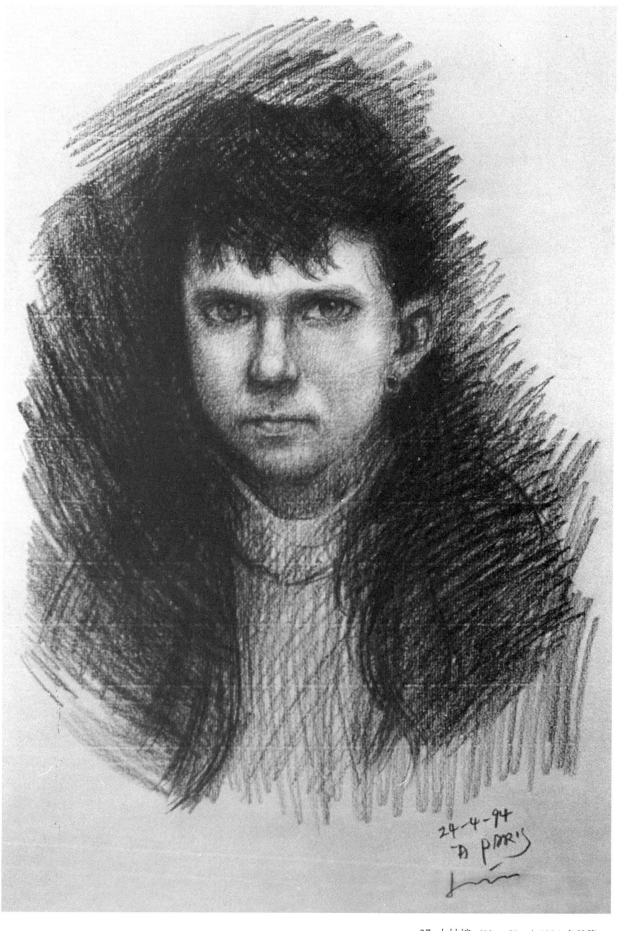

37. 小姑娘 *(32 × 50cm) 1994* 色粉笔

A little girl *pastel*

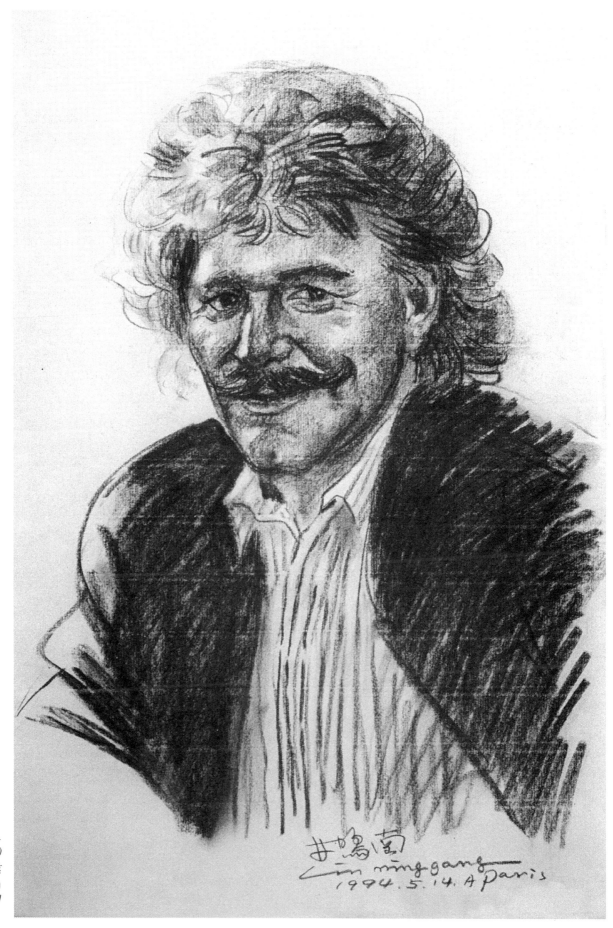

38. 微笑的人
(32 × 50cm)
1994 色粉笔
Smiling
pastel

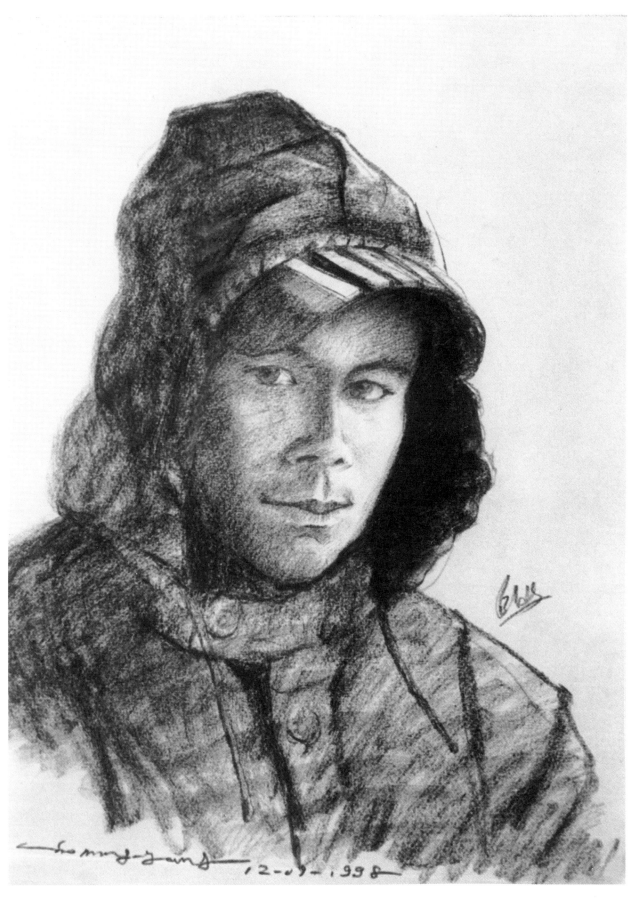

39. 躲雨者 *(32 × 50cm) 1998* 炭　笔
 Taking sheter from the rain *charcoal*

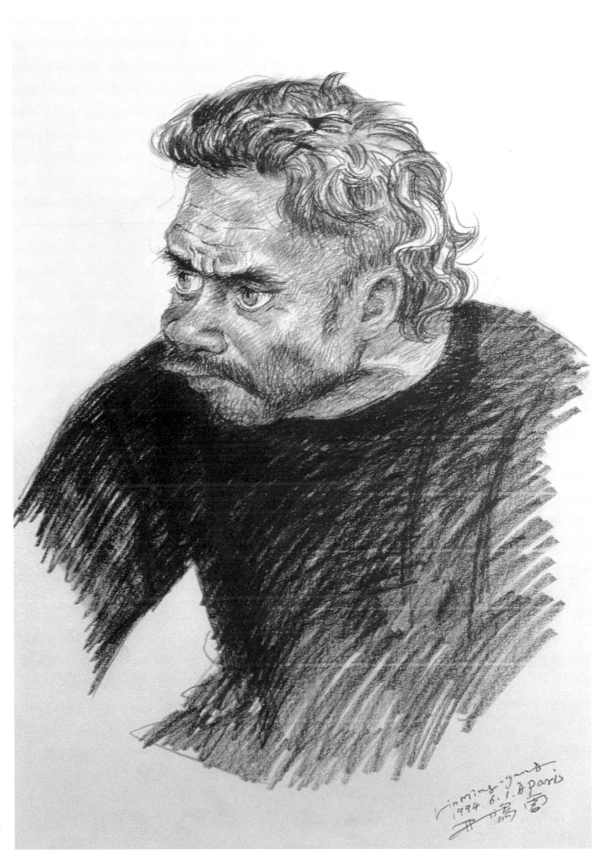

40. 神经汉
(32 × 50cm)
1994 炭 笔
The mad
charcoal

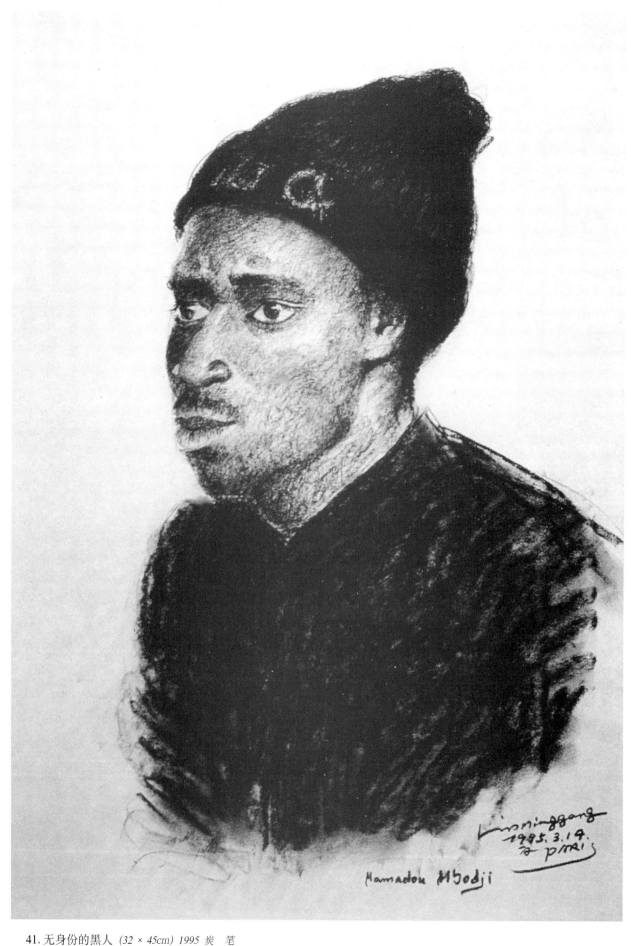

41. 无身份的黑人 (32 × 45cm) 1995 炭　笔
The Black without ID *charcoal*

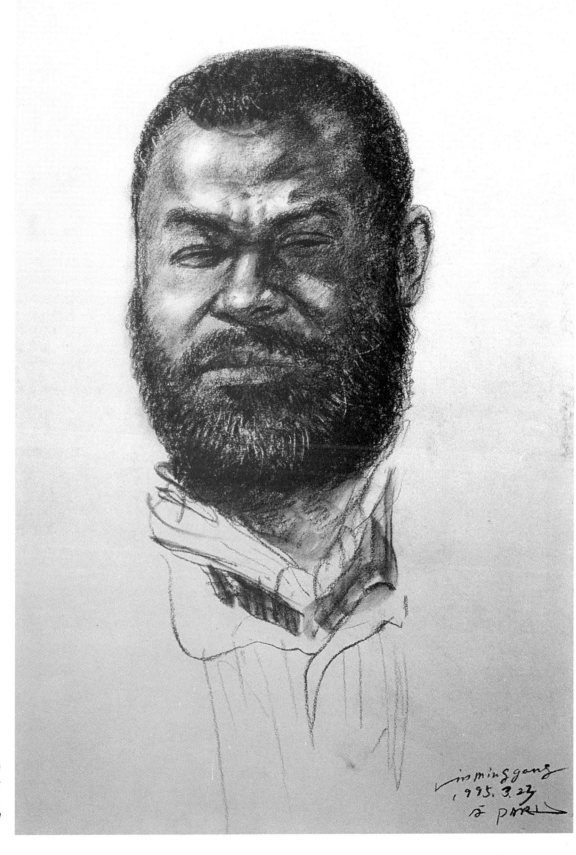

42. 无身份的黑人
 (32 × 50cm)
 1995 炭 笔
The Black without ID
 charcoal

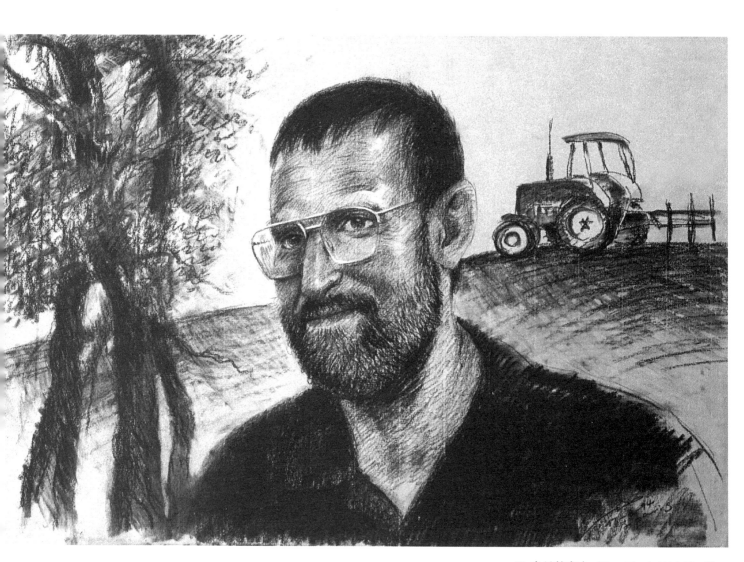

43. 自足的主人 *(32 × 50cm) 1994* 炭 笔
The owner with self-contentment *charcoal*

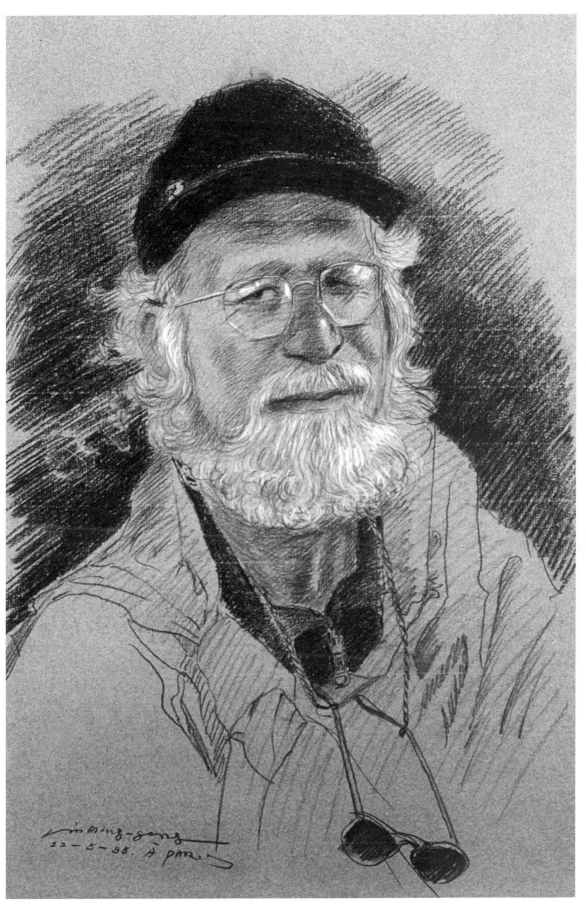

44. 旅行家
(32 × 50cm)
1995 炭 笔
Traveler
charcoal

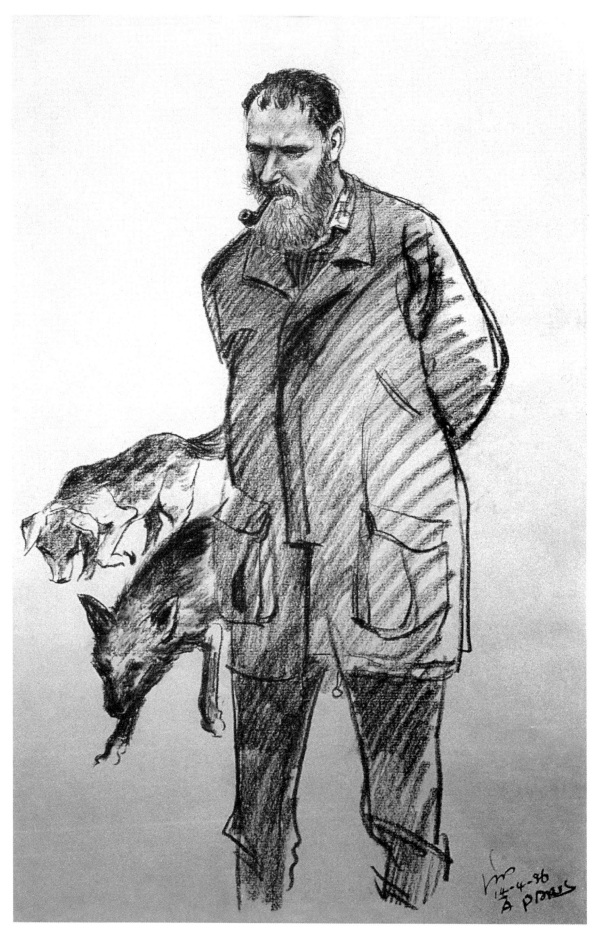

45. 闲逛者
(32 × 50cm)
1996 炭 笔
A vagrant
charcoal

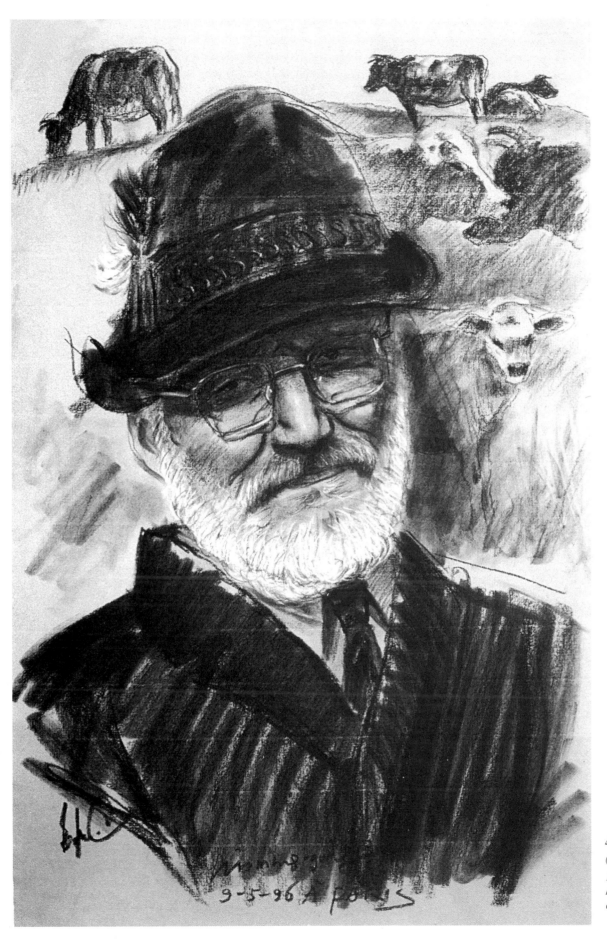

46. 牧牛人
(32 × 50cm)
1996 炭 笔
A cow-herd
charcoal

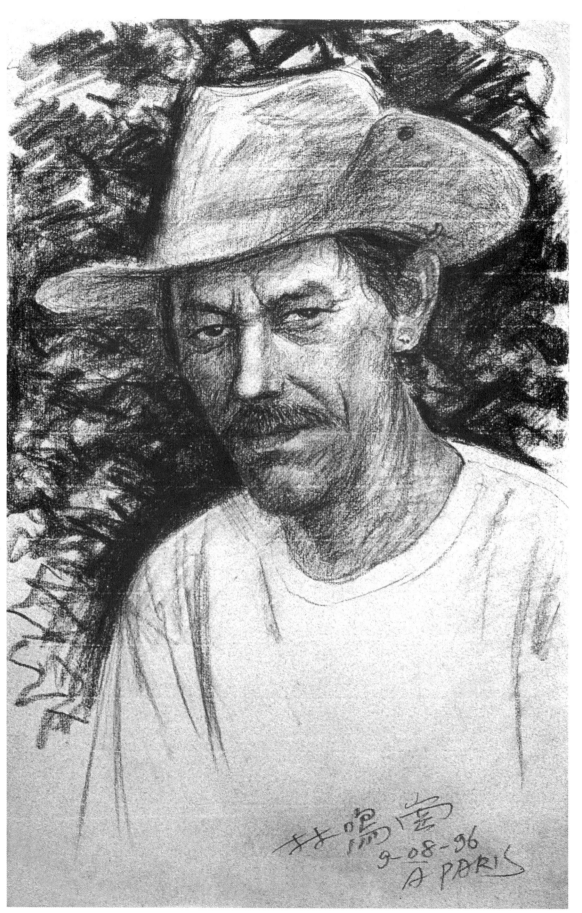

47. 自傲的人
(32 × 50cm)
1996 色粉笔
A man with self-importance
pastel

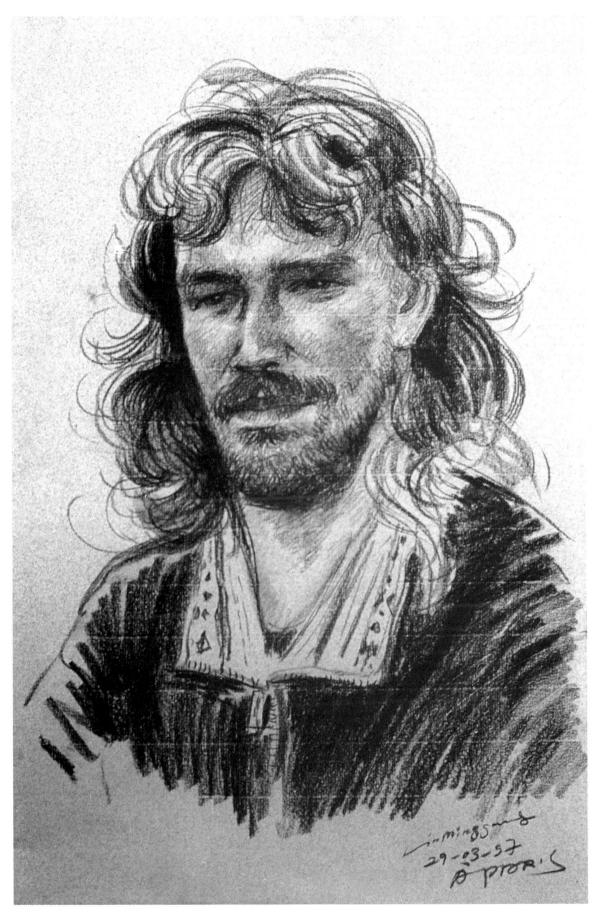

48. 男子汉
(32 × 50cm)
1997 色粉笔
Be a man
pastel

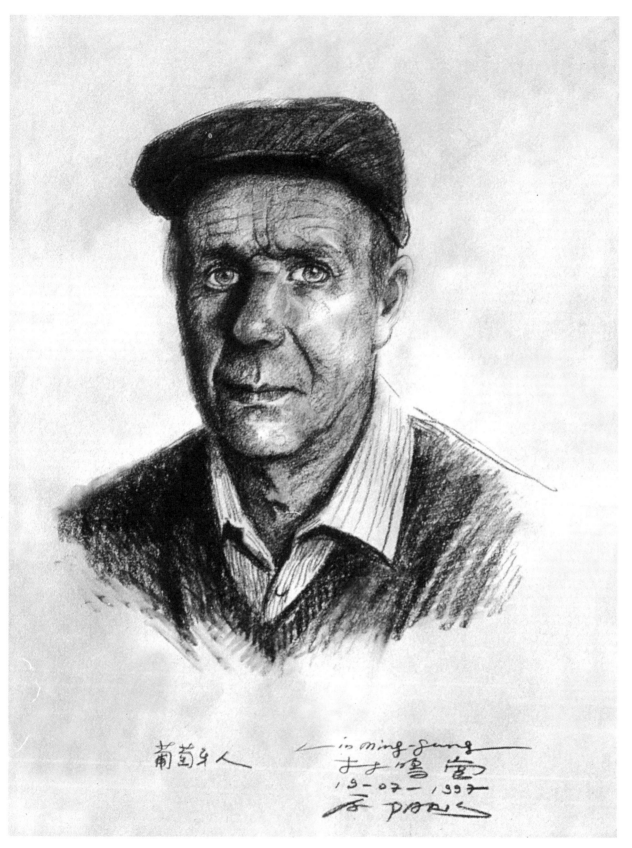

葡萄牙人

49. 葡萄牙人 *(32 × 45cm) 1997* 色粉笔
A Portuguese *pastel*

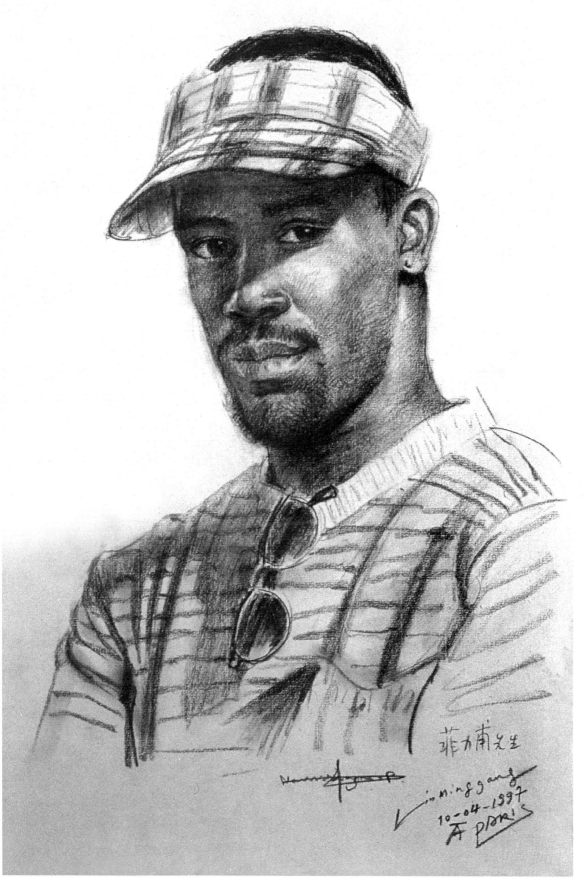

菲力甫先生

Liuminggang
10-04-1997
A PARIS

50. 凝视的青年
(32 × 50cm)
1997 色粉笔
Look pastel

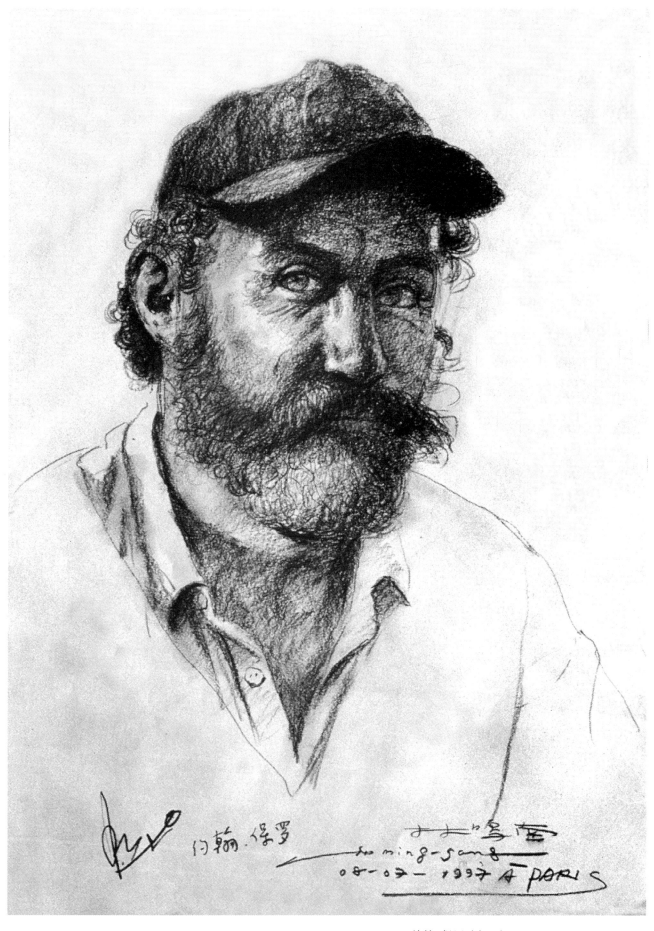

51.约翰.保罗（之一）（32×45cm）1997 炭 笔

John.Paul(no,1) *charcoal*

52.约翰.保罗（之二）（32×50cm）1997 炭 笔
John.Paul(no,3) *charcoal*

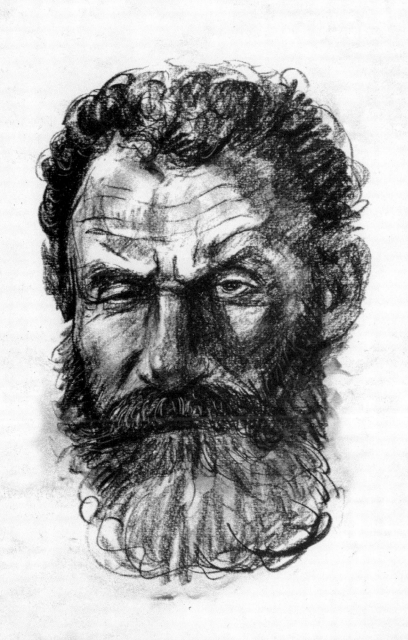

醉中 的朋友

1997. 08. 15.

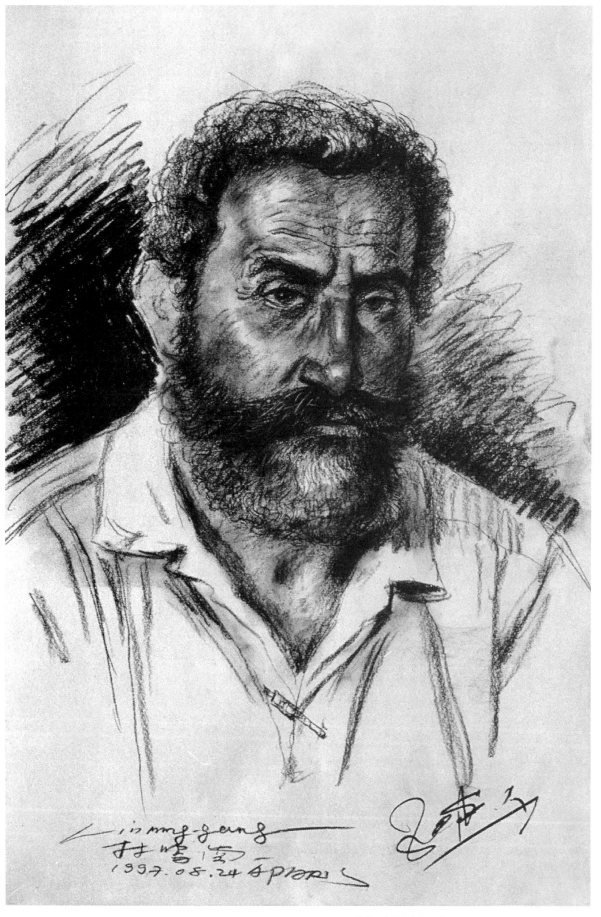

53. 约翰·保罗（之三）　(32 × 45cm) 1997 炭　笔
John.Paul(no,2)　　charcoal

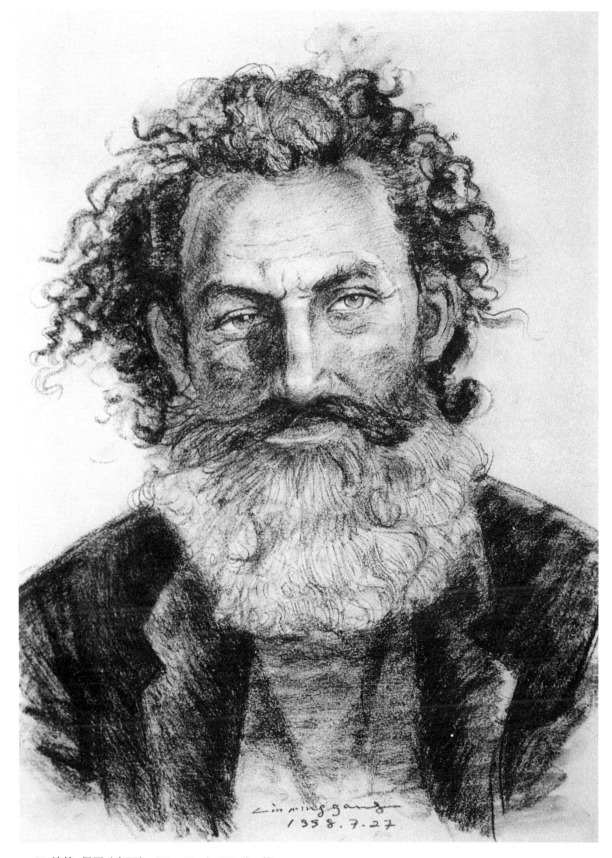

54. 约翰·保罗（之四）（32×45cm）1998 炭 笔
John.Paul(no,4) *charcoal*

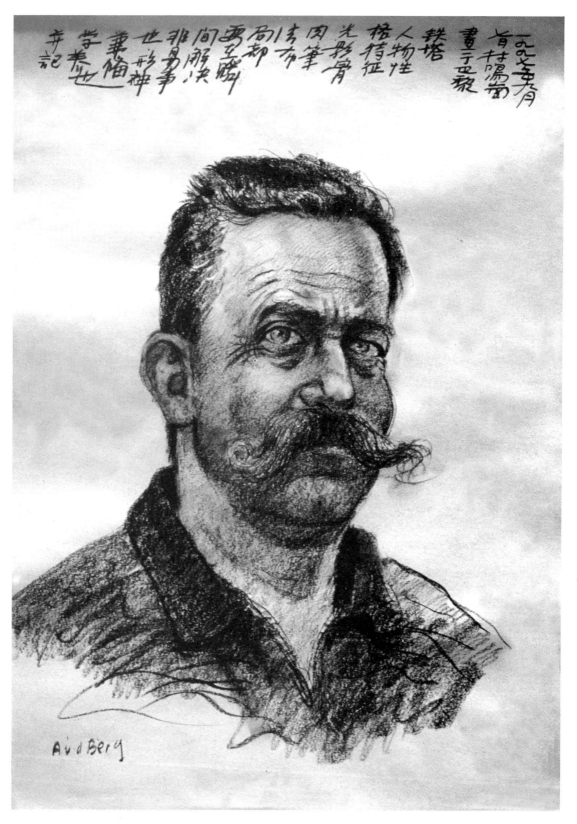

一九九七年春月

旨甚暢當畫于巴黎

揆塔

人物性格特征

光影肉骨筆法

毫无局部

具至一瞬间

要解決非易事也

世传神

柬偏

学恭也

辛记

55. 带笑的荷兰人 *(32 × 50cm)* *1997* 色粉笔
The smiling Dutch *pastel*

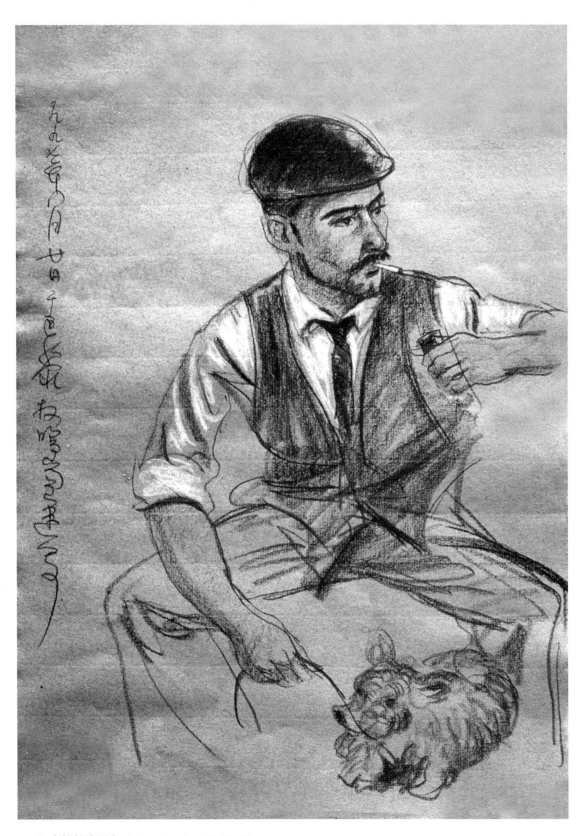

56. 点烟的法国人 *(32 × 45cm) 1997* 炭　笔
Smoking French　　*charcoal*

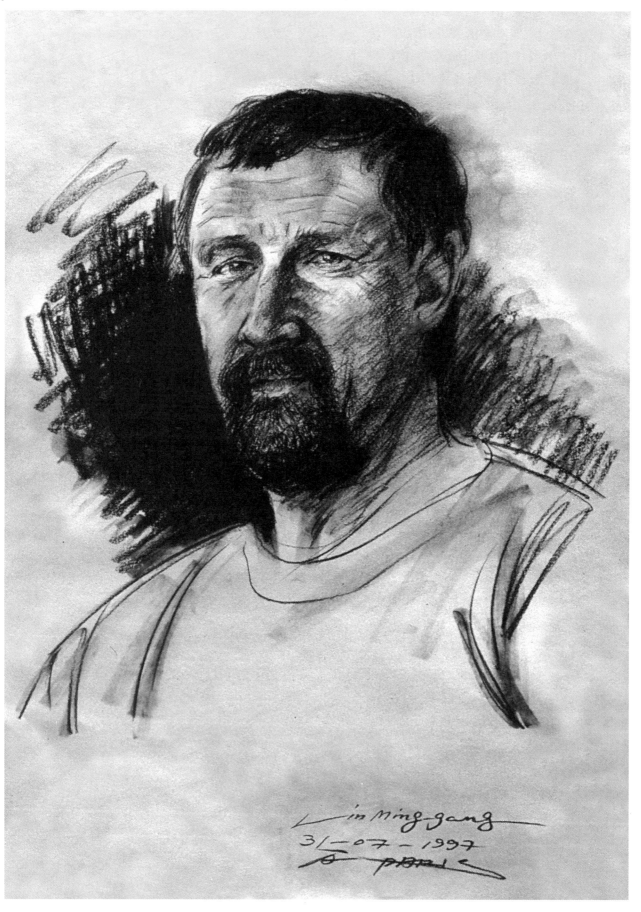

57. 穷人 *(32 × 45cm) 1997* 炭　笔

A poor man　*charcoal*

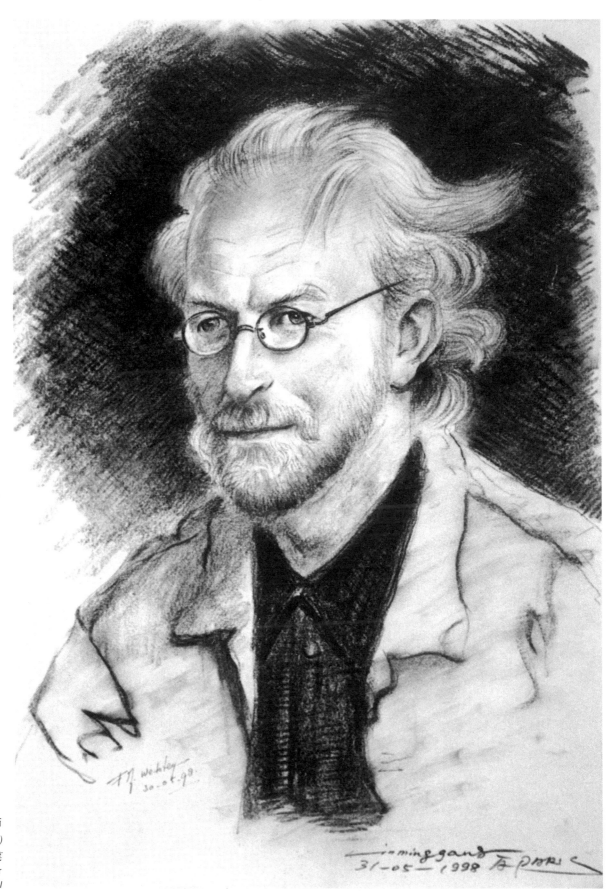

58. 一个老师
(32 × 45cm)
1998 炭 笔
A teacher
charcoal

人性的艺术

　　林鸣岗是一个有独特性格的画家。1990年，他怀着一颗虔诚的心从香港来到巴黎，一踏进这个后现代主义的奇异世界，马上受到那里新的多元文化现象的强烈冲击。各种思潮和观念、形式和风格、新和旧，让人琢磨不透，时间化为空间，直线化为平面，以"新"的独奏化为新旧和鸣。经过一段短暂时间伫立和疑虑，林鸣岗决然选择了一条纯粹的写实的道路，他要把人间的"真实"和"美"从一个世纪以来几乎消失的传统价值中重新找回。

　　他在1993年的一首诗中写到："无限的爱恨，无限的苦乐……一根飘动的头发，一条弯曲的皱纹，扣住了我的心弦。……"他像个少年恋人那样在自然的王国中歌唱。多少个赤日炎炎，多少个风雨交加的日子，焕发着生命的热力，不知疲备地奔走在塞纳河畔。

　　林鸣岗的肖像画洋溢着生命的充实和形象的真实感。七个漫长的春秋，画家作了成千上万幅头像速写，在长期的艺术活动中，他对社会进行了深刻的分析和思考，对各种生活形象反复观察。可以看出这些素描不是照相式的机械模拟，也不是学院式的循规蹈矩，这种既传统又人格化的表现方法全出自艺术家内心的呼唤。如果说波德莱尔认为"过度性、昙现性、或然性是现代艺术的一半"正确的话，那么艺术的另一半价值则是永恒不变的，它除了真、善、美以外，还有力、智慧、艺术的思辨和潜在的道德作用，林鸣岗的艺术实践正体现出这种价值的巨大魅力。

　　如果我们留意这些作品，会不难发现这集子三分之一形象里流露出惆怅、茫然和紧张的情绪，正是这些无法掩饰的感情，使这些肖像有了灵魂，反映出画家那健康、乐观的人生中包含着思索、焦虑和对社会的批判。这些众多而丰富的形象，犹如一面镜子，反射出当代社会的矛盾，涵盖着广褒的人性。

　　林鸣岗笔下的人物大部分属中、下层劳动大众，他们衣衫简陋，有时还能闻到一种酸味，但就是这些质朴而善良的人引起画家巨大的兴趣，他唱着："我爱他们，我接近他们，我不设防——我们是平等的朋友，他们如山、如草、如花，是生命的一部分。"语调中颇有法国思想家蒙泰涅文艺复兴后怀疑主义和万物平等的味道。林鸣岗喜欢这些普通的人是确确实实的，看那《流浪汉》、《无身份证的人》、《失业者》、《忧虑的人》、《没有自信的比萨》，画家都是带着欣赏的眼光来细察他们，即使他们有着生理或心理上的缺陷，这个乐呵呵的南方人还是用赞美的态度来表现他们美好的一面。如《哑巴》、《东尼妈妈》、《街头画家》等作品。当画家触到一些善良的人性时，他纵情歌唱，在《亚特拉小姐》和《伊丽莎白》那恬静的微笑及《失业者》安祥的神态中，再清楚不过地作了注解，这一切都流露出一个艺术家的坦诚、个性和感情。

　　虽然他的作品或多或少地存在着一些执著的拘谨和直率的不修边幅，但却掩盖不住他早年广泛吸收自古典主义至浪漫主义诸大师：荷尔拜因、益格尔、库尔贝、惠斯勒等技巧的明显影响。他出色地把握形体、光线和特征，既自由舒展，又明朗大方。使以前古典主义带有刻板造作的一面转换为具有时代气息和生动活泼的作风，同时又不失其严肃和深刻。因此，林鸣岗笔下的人物肖像非但栩栩如生，性格多样，并且充满着生命力和人性。

<div align="right">

旅法中国画家　方书聰

一九九七年三月八日于巴黎

</div>

The Art of Humanity

Ming gang Lin as an artist has fully developed his own unique style. In the early 1990s he uprooted himself from Hong Kong and came to settle in Paris in order to improve his artistic technique. An sincere and serious student, as soon as he stepped into this post-modern wonder world he was overwhelmed by the impact of its new multi-cultural phenomena. He was lost and confused in the maze of schools of ideologies and concepts, forms and styles, both new and old. "Time" became "Space", straight lines became surfaces and the new "Solo" became an ensemble of both old and new. After a short time spent pondering and doubling, Lin set out firmly on the route of pure Realism. He wanted to rediscover the path to the Classical ideals of "Truth" and "Beauty" which had been lost for nearly a century. He wrote in a poem in 1993:"Boundless love and hate,boundless bitterness and happines...A single flowing hair,One sinuous fold of skin,hold my heart."

He was singing in the kingdom of nature like a young man in love. Hot summers passed with the burning Sun, winters went by in storms and blistering wind. He continued tirelessly working beside the river seine to release the burning energy of lifeforce within him.

Lin's portrait paintings are brimming over with the fullness of life and are formed by his true sense of images.

In seven long springs and autumns he produced thousands of portrait sketches. During his long career as an artist he studied and analysed deeply the whole range of society. He made countless observations of images of people from every walk of life. The viewer clearly sees that these sketches are not automatic imitations of photographic style, nor rigidly literal depictions in a rule-bound academic style. The artist's approach to modern portraits, his treatment of life that is both traditional and individually humanistic, springs from genuine heart-felt emotion. If a famous critic was right in thinking that "transition, suddenness and accident make up half of Modern Art", then the other half would have to be formed from permanence and constant values. Apart from its truth, kindness and beauty ,art is also a judgement on power, wisdom and art's own potential moral function.Lin's art as we see it truely reflects the enormous magic power of such value.

If we carefully study these works of art ,we quickly notice that one-third of the portraits in this collection show emotions of melancholy,confution or stress and it is precisely these unconcealable emotions that have brought life and soul to these portraits ,they reflect the artist's meditations on the tension between his healthy optimistic view and his criticism of modern life , revealing the vastness humanity.

Most of Lin's sitters are from a middle or working class backgroud. Their clothes are often shabby, at times it seems you can even smell their and body odours. Howerver it is these simple but natural people who arouse the most interest in the artist. He sings: "I love them, I am close to them, no any barriers... we are equal friends. They are part of life like mountains, grass and flowers". His words resemble the philosophy ot the French thinker Montaine ,who defined Post- Renaissance scepticism and egalitarianism. Lin's liking of these ordinary people is very genuine, just take a lot at "The Homeless", "The Black with no ID", "The Unemployed", "The Sad" and "Bizat lacking in self-confidence". Each one was accurately observed with an appreciative eye by the artist. Even though the sisters may have been physically or psychologically challenged, the artist, always seeing happiness, paints to praise this subject's beautiful aspect, as in "The Speech Impaired", "Mother Tonia" and "The Street Artist". When the artist touches the kindnessof humanity, he is even happier in celebrating their good quality. The serene smiles in "Miss Atla" and "Elizabeth" and the calm mood in "The Unemployed" more than cearly illustrate this strong point. All his work shows the frankness, individuality and true emotions of the artist.

Although his works still show some stubbornness and unflattering frankness, they cannot hide the obvious influence in his technique by such artists as Holbein, Ingre, Cubert and Whistler. During his early years of study he absorbed widely the essence of the great masters of both the Classical and Romantic movements. He successfully mastered the techniques of form and light, while adding a freedom of spirit and a luminous sense of beauty; special features that transformed the staleness and artificiality of the former Classicism into a style that is full of cotemporary liveliness while retaining the former's seriousness and profundity. This is why the portrait figures that come from Lin's pen are not only full of life with a multitude of personality but also full of vitality and humanity.

Fang Shi cong
8th March 1997

Fang, a well-established Chinese oil painting artist born in Shanghai, China, now living in Paris, France
Translated by Eileen GAO, Translator and writer, now Living in London.
Corrector: Kathy Rosen(U.S.A)

目 录

Contents

作者简历

林鸣岗（原名：林民刚）

1952	生于福建省福清市
1968	毕业于福清华侨中学
1970-1976	到古田县上山下乡
1978	移居香港
1984	毕业于香港美术专科学校
1990	移居巴黎
1990-1992	深造于巴黎国立高等美术学院

获奖

1989	首届全国民俗绘画大展（西安　二等奖）

个展

1989.1.5-1.11	香港艺术中心（香港）
1992.9.3-9.29	"Yves Fay"画廊（巴黎）
1993.12.10-12.20	"光华画廊"（巴黎）
1994.11.3-11.10	香港新中银大厦（香港）
1999.6.3-6.10	光华新闻文化中心（香港）

联展

1985	国际青年年画展（北京）
1987	写生考察印尼、巴厘岛、新加坡
1988	香港美术家作品展（福州、武汉、香港）
	22届国际绘画大展（摩纳哥）
	写生考察菲律滨、泰国
1989	第七届全国美术作品展（北京）
1990	26届国际现代绘画大展（东京）
1990.9.29	抵荷兰
1990.11.23	抵巴黎
1991	"秋季沙龙"（巴黎）
1992.3-4	写生考察威尼斯、佛罗伦萨、罗马
	"秋季沙龙"（巴黎）
1993	国立美术协会大展1993（巴黎）
	法国艺术家沙龙（巴黎）
	"秋季沙龙"（巴黎）
1993.10-11	写生考察荷兰、波恩、科隆、慕尼黑
1994.1.8	考察罗马、佛罗伦萨、威尼斯
	"三角"画廊（巴黎）
	"秋季沙龙"（巴黎）
1995.12	文化中心（巴黎）
	"中国名家书画展"（香港大会堂）
1996	"中国名家书画展"（香港大会堂）
1996.11.30	写生考察威尼斯、佛罗伦萨、罗马
1998	"香港速写展"（香港）
1998.3-4	考察纽约、波士敦
1998.8-10	Galerie　Rueil　Horizon（92500法国）
1998.9	考察伦敦
1999	"李氏画廊"

著作：《林鸣岗巴黎油画近作选》	1993年出版
《林鸣岗素描肖像集》	1999年出版
《林鸣岗油画选》	1999年出版

RESUME

Lin Ming gang (Alias,Lam Man-Kong)

1952 Born in Fuqing city,Fujian Province,China

1990-92 Appoint as visitor artist of Paris National Arts Academy.
 (ECOLE NATIONALE SUPERIEUR des BEAUX-ARTS de PARIS)
1990 Settle down in Paris.
1984 Graduated from Hong Kong Fine Art Academy School
1978 Immigrated to Hong Kong and started paintings career
1968 Graduated from Hua-Qiao High School

Prizes And Awards:

1989 Second Prize The First National Custom Paintings Competition of China Xi'an

One-Man Exhibitions:

1999 'Kwang Hwa Information & Culture Center',Hong Kong
1994 'Bank of China',Hong Kong
1993 'Galerie Guanghua',Paris
1992 'Galerie Yves Fay',Paris
1989 'Hong Kong Art Center',Hong Kong

Main Exhibitions:

1999 'Gallery Klee',Hong Kong
1998 'Galerie rueil horizon',France
1997 'Hong Kong Cultural Center',Hong Kong
1996 'Hong Kong City Hall',Hong Kong
1995 'Hong Kong City Hall',Hong Kong
 'Space of Culture',Paris
1994 'Triangle Galerie',Paris
 'Salon of Autumn',Paris
1993 'National Arts Association 1993',Paris
 'Salon of French Artists Association',Paris
1992 'Salon of Autumn',Paris
1991 'salon of Autumn',Paris
1990 '26th The International Public Collection Asia Modern Art Exhibition',Tokyo
1989 'The 7th China Art Exhibition',Beijing
1988 '22th International Art Exhibition',Monaco
 'A Join Exhibiton of Work by Hong Kong Artists',Fuzhou,Wuhan,Hong Kong
1985 'International Youth year's Exhibition',Beijing

Book: "Lin Ming-Gang's Oil Paintings in Paris" (1993)
 "Lin Ming-Gang's Portraits Drawing" (1999)
 "Lin Ming-Gang's Oil Paintings" (1999)

图书在版编目(CIP)数据

林鸣岗肖像素描集／林鸣岗编绘.
－郑州：河南美术出版社，1998.12
（当代名家素描画典丛书）
ISBN 7-5401-0770-7
Ⅰ.林… Ⅱ.林… Ⅲ.人物画:
写生画－作品集－中国－现代 Ⅳ.J224
中国版本图书馆 CIP 数据核字(98)第 36814 号

林鸣岗肖像素描集 —— 当代名家素描画典丛书

林鸣岗　编著　　　　　　　　　　责任编辑 李学峰
河南美术出版社出版发行　　　　河南第一新华印刷厂印刷
850 × 1168毫米　　大 16 开本　　4.25 印张
1999 年 10 月第 1 版　1999 年 10 月第 1 次印刷　印数: 1-3000 册

ISBN 7-5401-0770-7/J₂·655　　　　　　定价: 18.00 元